THE SPIRIT OF TEQUILA

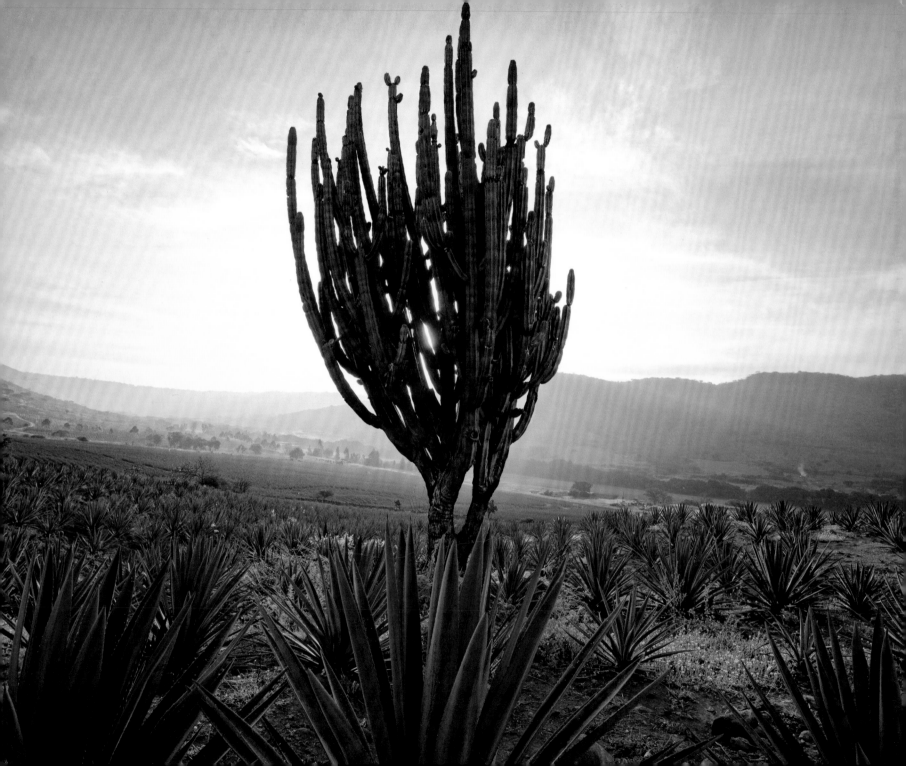

THE SPIRIT OF TEQUILA

PHOTOGRAPHS BY JOEL SALCIDO

Foreword by Paul Salopek ·· Introduction by Chantal Martineau

TRINITY UNIVERSITY PRESS | SAN ANTONIO, TEXAS

Para mis más queridos, Rosie, Bryana, y Cid. Y por supuesto, para Toñita.

CONTENTS

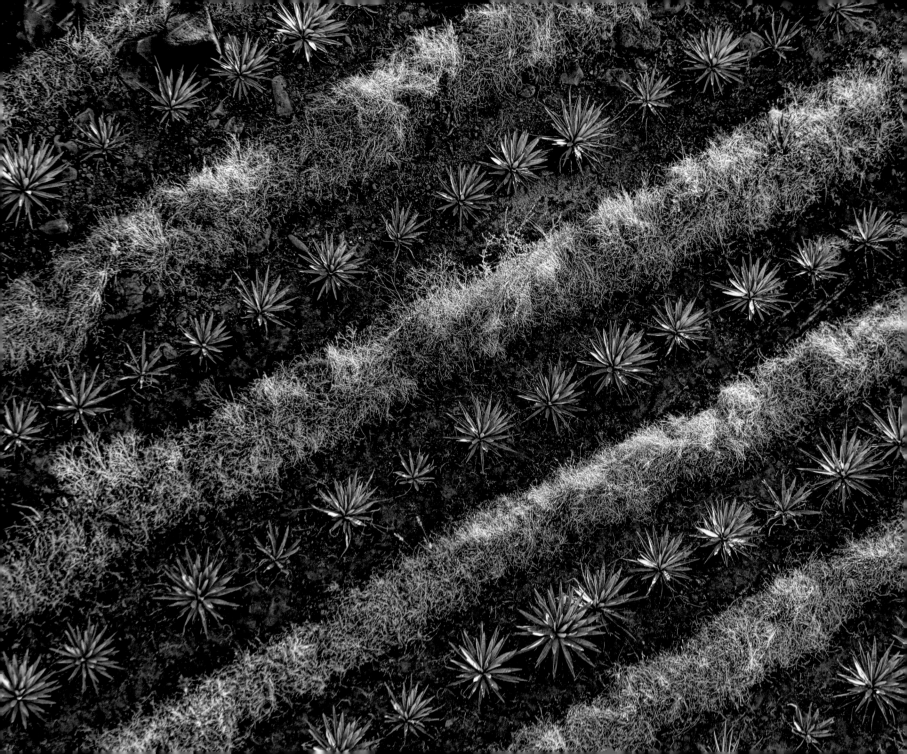

FOREWORD

Paul Salopek

Agave tequilana "Weber Azul" is a delicate and waxy blue, like certain hues of woodsmoke, or like the blued shadows that pool in the rincons of the Sierra Madre Occidental, the wild mountain range that knuckles down the western edge of the Mexican state of Jalisco.

I grew up in Jalisco, the birthplace of tequila, the famed spirit these blue agave plants so generously yield. Blue agaves lined the dirt streets of my *colonia*. We schoolboys carved our names and much worse into their fleshy spikes of leaves. We deployed their tall flower stalks—some towered so high they poked rain out of the passing gray monsoon clouds—as spears. Once we were old enough, and sometimes not old enough, we sipped the fermented juices of the blue agave, a universal rite of passage in the Mexican altiplano.

Unlike its brother and sister liquors (whiskeys, gins, vodkas, chachas, ryes, bourbons, scotch, etc.), the raw material of tequila is neither seeds nor roots. No, it is the plant's very core, its heart. The good *jimador* walks his glaucous blue fields—in the gentle foothills, let's say, above old Zapopan—appraising his crop before the harvest. He looks for many things: The cactuslike agaves must be between four and eighteen years old to give up their best juice. The moisture in the soil and season of the year are also important. The dry weeks just before the first rains are best, as they concentrate the sugars in the agave's swollen *corazón*.

The good harvester is always listening to this enigmatic heart. He knows that within it beats the wing-flick of the bat that pollinated his plants. It holds the pulse of the yellow sun, the long, lingering cores of summer afternoons. It drums with the raindrops that in Mexico fall straight and silver and hard. He takes the agave's heart in his rough hands and squeezes its essence into a small glass. He offers it up to you.

I regret to report that I do not drink tequila often anymore. My body has seen too many wars. But I remember the color of those plantations—their mesmerizing cool hues in the rippling heat of the subtropics. The blues of childhood.

PREFACE

Tequila, like Mexico, is *mestizaje*—a coalescence. When pulque, the fermented nectar of Mexico's indigenous world, embraced the Spaniards' copper *alambiques*, or stills, tequila was born.

Mexico's iconic drink is deeply rooted in a past that is both complex and immense. As early as the sixteenth century, the national drink of Mexico was known as *vino de mezcal*, from the Spanish word *vino*, for wine, and the Nahuatl word *mezcal*, for agave.

The *mezcal* of the Nahuatl culture played an enormous role in the lives of Mesoamericans. Not only was agave critical for sustenance; it could also be used in the making of shelter, clothing, and tools. Mayahuel, a Venus-like divinity that personifies the maguey plant, became the symbol of fertility for the Aztecs.

The town of Tequila, or Tecuillan, Nahuatl for a "place of work and cutting," is where land, agave, and people came together to produce the iconic spirit of Mexico. It is here, and in other towns in Jalisco, that I set out to explore the contemporary world of tequila. My search led me to the holy trinity of tequila makers—Cuervo, Herradura, and Sauza—which began in 1758 with Cuervo's mass distillation of blue agave sugars. I also sought out artisanal *tequileras* committed to the traditional craft of tequila-making, from harvest to bottle.

In this landscape of blue agave, I discovered traditions of culture and religion—ancient and modern, indigenous and foreign. All were a reminder of my own complex Spanish and Native American mestizo heritage. Childhood memories resurfaced, decades after I stepped across the Rio Grande into the United States as an immigrant child of seven.

The photographs from this journey reflect the mystical space where the weight of history and the bounty of the earth blend into a spirit called tequila. It is the elixir that remains the guardian of Mexico's landscape, tradition, and identity—indeed, the ancient lord of fire with a savage smile.

INTRODUCTION *Chantal Martineau*

A silvery blue plant. A crystal clear liquid. How one becomes the other isn't a miracle. It involves science, craft, and a good deal of hard work. The iconic liquid export, distilled from the native blue agave plant, has been made in Mexico for at least four hundred years—some believe centuries longer. The spirit and its raw material have been intricately tied to Mexico's history, culture, and mythology since the time of the Aztecs.

Most of us don't think of tequila as a cultural product. Maybe the idea that a bottle on the back bar at the local watering hole might be culturally and historically significant doesn't occur to us. Or perhaps it's the memory of that first (or worst) experience with the spirit. Shots with salt and lime, or frozen margaritas—these were once the standard introduction to tequila.

These days tequila is often sipped neat, like fine scotch or cognac, or mixed into artisanal cocktails that have nothing to do with a margarita, much less a premixed one. The spirit comes bottled in exquisite crystal decanters, and a number of brands are backed by celebrities or billionaire entrepreneurs. It's not just that the spirit has changed—although it has, as much better incarnations are more readily available than decades ago. Public perception of tequila is also shifting. No longer is it deemed party fuel, something to be slammed during spring break by hooting coeds. It can be a spirit with sophistication and intrigue. And yes, it is a cultural symbol for Mexico, one with a rich and complicated history. Just how it evolved from a rustic regional specialty to a luxury good is a long and winding tale.

It's a story that begins with a native plant, an extraordinary plant, called agave. Agave are large perennial succulents that look like aloe and are often mistaken for cactuses. Taxonomically speaking, they are more closely related to asparagus. More than two hundred varieties exist, and almost all are indigenous to Mexico. Blue Weber (*agave tequilana*) is the variety used to make tequila. Many others, like espadín, the genetic ancestor of blue Weber, are used to make mezcal. Henequén, a variety that thrives in the southern part of the country, was widely used in textile manufacturing in the early part of the twentieth century (until DuPont invented nylon in the 1930s, devastating the henequén industry).

Take a drive through tequila country and you'll see waves upon waves of steely blue from the road. These are agave fields. Researchers believe that agave has been consumed in Mexico for at least eleven thousand years, making it one of the earliest cultivated crops in the Americas alongside squash and maize. Agave was used for everything from food and shelter to cultural production. Early Mexicans were known to weave its dried leaves into clothing, bedding, and roofs for their homes. The fine needle at the tip of each spiny leaf was used to sew fabric and for drawing, and in the bloodletting ceremonies the Aztecs were so fond of. This deep reliance and connection to the agave is echoed in its prominent place in Aztec mythology.

Mayahuel is the deity most often associated with agave. She is often depicted as having four hundred breasts to feed the Centzon Totochtin—the four hundred rabbit gods of intoxication. Numerous

versions of the legend exist, but most begin with Mayahuel's grandmother, the evil goddess Tzitzimitl, who lived in the heavens and devoured light. Mayahuel lived with her grandmother, sleeping all day and night, in a perfect state of wellbeing. One day the god Quetzalcoatl decides to fly up to the heavens to destroy the evil goddess. Instead he finds Mayahuel. She awakens, and they fall in love at first sight. Quetzalcoatl takes her back to earth so they can be together, but they are forced to hide from Tzitzimitl, who is livid at her granddaughter's disappearance. The couple hides in different places around the earth until, finally, they decide to disguise themselves as a tree. Tzitzimitl discovers them and, in a fury, rends the tree in half, killing Mayahuel. Quetzalcoatl flies into a rage and destroys Tzitzimitl. He returns to his lover's remains

and buries them. The first agave sprouts from the dirt that covers her bones: a gift from the gods. Quetzalcoatl drinks its sweet sap and rejoices.

Thousands of years before tequila was made, Mesoamerican tribes brewed pulque, a sort of beer, from the agave's fermented sap, called aguamiel (honey water). This tart, milky, mildly effervescent drink was taken during sacred rituals as a way to commune with the gods. The Aztecs deemed it sacrosanct and prohibited common consumption. Pulque was for the exclusive elect—holy men—to drink during religious ceremonies. Public drunkenness was punishable by death, but pulque was prescribed to the sick, the elderly, and pregnant women. Spanish conquistadors disapproved of pulque and called for a ban on the drink, but it didn't last long. The Spanish Crown soon came up with

a better solution: to tax pulque. By the mid-eighteenth century, the tax collected on pulque was one of Mexico's most important sources of government revenue.

It's been said that the Spanish brought distillation to Mexico, as they did to the other parts of the New World they conquered. But Mexican researchers have collected evidence suggesting that indigenous people were distilling long before the Spanish invaded. Early artifacts have been found near the Colima volcano, in the state of Jalisco, not too far from the heart of tequila country. The artifacts included vessels that may have been used to distill agave and figurines depicting people drinking from tiny cups, much smaller than those used for pulque. Could it have been mezcal? Scientists on both sides of the border are studying these artifacts, said to date as far back as 1500 BC.

Whoever brought distillation to Mexico, it was early Mexicans who applied it to agave. The technology spread from pueblo to pueblo until communities across the region were distilling the agave varieties that were indigenous to the area. The spirit was named mezcal, from the Nahuatl *mexcalli*, a combination of the words for agave or maguey (*metl*) and oven-cooked (*ixcalli*). What we know as tequila was once one of Mexico's many *mezcales*, known as *mezcal de Tequila* or, more accurately, *vino de mezcal de la región de Tequila*.

Tequila, like Champagne or Cognac, is not just the name of a product but also refers to a place. The small town in the state of Jalisco is about an hour's

drive from Guadalajara, Mexico's second-largest city. The mezcal from Tequila was widely known to be of high quality and, given its proximity to Guadalajara, had a ready-made clientele. By the late nineteenth century, the wealthiest and most famous tequila-producing families in town—the Cuervos and the Sauzas, who still produce some of the biggest brands today—decided to try taking their spirit across the border. Mezcal de Tequila was entered into spirits competitions in the United States and was soon being sold under the moniker Mexican whiskey or Mexican brandy. Americans liked this Mexican whiskey, and its popularity north of the border boosted its popularity back home. Soon mezcal de Tequila became known simply as tequila.

The process for making tequila has evolved since the earliest days of the Cuervos and the Sauzas. But the role of the *jimadores*—the men tasked with harvesting agave for tequila production—has remained the same, passed from generation to generation. It's still common to find families working the fields together—fathers, sons, brothers, uncles, cousins. The jimador is a symbol of Mexican fortitude and resilience. The harvest, or *jima*, is backbreaking work. Each plant must be dug out of the ground at the root—no small task at up to two hundred pounds each. The jimador uses his *coa*, a rounded hoe, to slice off the agave's large, heavy leaves. When he's done, nothing is left but the heart, known as the *piña* because it looks like a pineapple. This part of the plant gets trucked to the distillery to be cooked, crushed, fermented, and distilled into tequila.

In wine production, connoisseurs talk about terroir. It's a term from the world of French wine that refers to the way the soil, climate, elevation, and topography of a place are married to influence the flavor. Tequila, too, can express terroir. In the Tequila valley, the soil is volcanic and ashy gray, and the piñas grow earthy and spicy. In the highlands, where the soil is brick red and iron-rich, the agave ripens fruity and sweeter. The higher altitude, six thousand feet and more above sea level, translates into drier, sunnier days and cooler nights, and local tequila producers believe the fluctuating temperatures result in more complex flavors. Valley producers, for their part, lay claim to the oldest agave-growing lands. At up to four thousand feet in elevation, the area is misleadingly referred to as the lowlands.

Once the piñas arrive at the distillery, they must be cooked, as the Aztecs' word for mescal—*mexcalli*, or oven-cooked agave—implies. This can be done in several ways. Traditionally, the halved or quartered piñas are loaded into a brick oven, where they are steamed over several days until they are brown and caramelized. More modern facilities use an autoclave, a sort of pressure-cooker that takes less time and can impart more floral and citrus notes to the tequila. High-volume brands tend to use a diffuser, a machine the size of a train car that processes the agave using hot water.

After cooking, the agave is milled. Few distilleries are still equipped with a tahona, a traditional stone mill that consists of a two-ton wheel carved out of volcanic rock affixed to the center of a round stone pit. The wheel is turned around and around,

either pulled by a mule or a mechanized tractor, and gradually crushes the cooked agave on the pit's stone floor. The juices from the crushed agave are collected into fermentation tanks. Most distilleries today use a mechanical shredder, a contraption borrowed from the rum industry for use in grinding sugar cane.

During the fermentation stage, the agave mash sits in wooden or steel vats, bubbling and frothing as it slowly converts its sugar to alcohol. A number of distilleries rely on ambient yeasts—already present in the distillery, floating in the air, and on the very skins of the plants—while others inoculate their mash with synthetic or lab-raised yeasts. It usually takes a few days for the yeasts to devour the sugars, leaving alcohol in their wake. The process also produces carbon dioxide, which escapes into the air.

Distillation is the final step in making tequila. Most distilleries use alembic copper pot stills to bring the liquid to a boil and trap the alcoholic vapors. The distiller's job is to separate the volatile first part of the distillate, known as the heads, and the methanol-heavy second part, known as the tails, from the best part of the distillate, the heart. After two distillation runs, the resulting tequila can be bottled as is, clear and un-aged. This is known as *plata* (silver) or *blanco* (white) tequila and is most often enjoyed mixed into cocktails, although purists prefer to sip it neat. Alternatively, the liquid can be put into oak barrels—usually former American whiskey or bourbon barrels—for aging. A *reposado* (rested) tequila is aged from two months to just under a year, at least a year is required for *añejo*, and a minimum of three years is required for *extra*

añejo. Reposado tequila, with its gently caramelized notes, is often used in cocktails. Añejo and extra añejo tequilas tend to be served on their own, similar to a good after-dinner whiskey or brandy.

Over the years tequila's popularity has ebbed and flowed. In Mexico, a number of tequila producers recall their parents or grandparents drinking it only on the sly. In polite company, scotch or cognac was served. In the United States, tequila has experienced a few surges in popularity, such as during Prohibition. Just as Canadian whiskey flooded the border to the north, tequila was smuggled into southern states, to the delight of thirsty Americans. Later, the crooner Bing Crosby became involved in the business of importing tequila after traveling to Mexico and falling in love with the Herradura brand. In 1958 the hit song "Tequila" (and its unfor-gettable refrain) by the Champs brought the spirit renewed attention. Another song, Jimmy Buffett's "Margaritaville," hit the charts in 1977. By the 1990s the United States was in the grips of a full-blown tequila boom, but it would be some years before Americans discovered "good" tequila. At the time, there was no such thing as a premium label. The shots and margaritas flowed.

You might say we are currently experiencing a second boom. In the last decade or so we've seen an influx of luxury tequilas made from 100 percent agave. Most people don't realize that their first—or worst—tequila probably fell into the category made with just 51 percent agave distillate and up to 49 percent unnamed "other sugars" (typically derived from corn or sugar cane). For decades 100 percent agave tequila was hard to come by. What's more,

consumers weren't educated enough about tequila to know that they might prefer it. The spirit came to the United States and spread around the world with no shortage of myths about psychotropic side effects and worms at the bottom of the bottle. There was little information about its true origins.

The rise of 100 percent agave tequila should be considered a boon. After all, it's a purer, more traditional take on tequila, harkening back to the days when all tequila was 100 percent agave. It wasn't until the mid-twentieth century, as demand started to swell, that producers grew concerned over agave shortages. To keep up with demand over the next two decades, they incrementally reduced the amount of agave required in tequila. In 1974 tequila earned its appellation of origin, a status that, like Bordeaux wine and Comté cheese, iden-tifies it as a distinct product associated with a spe-cific geographic region. It was a crucial step in the fight against counterfeiting and adulteration of the spirit. Legally, to be called tequila, the spirit must be made according to strict regulations and within a designated region comprising the entire state of Jalisco and municipalities in four other states: Guanajuato, Michoacán, Nayarit, and Tamaulipas. By the time the appellation of origin was achieved, however, the amount of agave required in a bottle of tequila had been cut to about half. The rest of the ingredients could come from anywhere.

It's baffling to think that a bottle of tequila, Mexico's iconic liquid export, could be half, well, not tequila. But as demand for tequila grew over the years, shortages and their proposed solutions became inevitable. Blue agave is no easy plant to

farm, and the market for it is volatile; the price rises and falls like that of oil or gold. The seemingly unbreakable cycle of gluts and shortages can largely be attributed to the nature of the plant. Think of the usual variables farmers contend with—extreme weather conditions, pests, disease—and multiply these by seven years, which is, on average, how long it takes agave to reach maturity. (Other varieties of agave can take ten, fifteen, twenty, even thirty years to ripen.) Consider grapes; they ripen over a season and grow back each year. But once an agave plant is harvested, it dies. Another must be planted in its place.

It's all part of the romance of agave. A nocturnal plant, it comes alive at dusk. In the wild, an agave grows a tall stalk, a *quiote*, from its heart. This is its sexual organ. At the top of the stalk sprout tiny flowers, which are pollinated by all sorts of nocturnal creatures. Moths and bats are drawn to the agave's flowers, which open to release their heady perfume as the sun is setting. These night fliers feed on the flowers and scatter their seeds. For the purpose of tequila production, the quiote is cut, conserving all the plant's energy for growing a big, sweet heart. The plant is propagated asexually, using cuttings, the way you might with a house plant. Agaves grow shoots, called *hijuelos*, which can be cut and replanted to flourish on their own. Some researchers have warned that multiple generations of this type of cloning threatens the plant's genetic robustness. Farming as a monoculture already reduces biodiversity within the plant popu-

lation. Sustainable growing practices are a top concern for many tequila producers, and several studies into the plant's genetics have been initiated.

For the time being, tequila is experiencing a true golden age. The world's love affair with the spirit has grown the category about 150 percent since 2002, and today the industry benefits some seventy thousand families in Mexico. The premium sector has ballooned some 700 percent over the same period. Now is a good time to drink good tequila, to be sure. When shopping for a bottle, keep an eye out for a few things. First, look for the phrase "hecho en Mexico" (made in Mexico). It's the front line in the battle against counterfeiting. Second, look for the mention of 100 percent agave. This helps ensure that you're drinking a high-quality spirit made with

an eye to tradition. Finally, check the NOM (*norma oficial de México*) number, located on every bottle of bona fide tequila. This will tell you what distillery the spirit was made in. Only about 150 distilleries exist within the boundaries of the tequila region, but there are at least 700 brands. In other words, most distilleries make multiple labels. By the same token, many brands that are exported are not available domestically and vice versa. A few gems are available both to Mexicans and abroad and are well liked on both sides of the border.

Thankfully, shots with salt and lime are no longer the most accepted way to drink tequila. In enlightened circles, they're downright frowned upon. It's certainly not a traditional way of enjoying the spirit. In Mexico it is sipped and often paired

with *sangrita*, or "little blood"—a nonalcoholic drink, usually tomato or fruit juice based, with a kick. Sangrita's acidity is said to complement the acidity in the tequila. They make for a great aperitif, opening up the appetite for a meal. As for margaritas, they shouldn't be avoided, by any means, but they aren't the only cocktails being made with tequila. There are Manhattan variations made with reposado and contemporary twists on the Old Fashioned that use añejo. But a classic, refreshing margarita, one made with fresh-squeezed lime juice and maybe a dash of pure agave nectar, is nothing to sneer at. Made with great tequila, it can be a great drink.

For a true purist, a glass of good blanco, served neat, is ideal. Its aromas transport you to the rolling green foothills of Jalisco, blanketed in blue. Here the jimador harvests the imposing plants and the distiller turns them into liquid silver, and it becomes obvious that tequila is not only a cultural product but also an agricultural one—the essence of a swath of land and the people who work it, distilled.

At sunrise, light came calling. I set out from Atotonilco el Alto, in Jalisco, en route to the most Mexican of towns—Arandas. Fields of blue agave flanked the road as if standing guard over the spirit that once fueled the Mexican Revolution. The morning was crisp, and the sun hid behind a mountainside.

A day or two earlier I had studied the landscape, and I knew I could make some compelling images if the light was good.

The rows of agave were symmetrical, as they had been for the past six to eight years and would remain until the harvester, the *jimador*, came calling. The jimador must be a master of his craft; the sharp daggers of the agave are merciless and unforgiving. They demand respect.

As my eyes scanned the hills, I saw movement. (Movement will always stop a hunter as well as a photographer, likely because reportage photography is half hunt and half art.) A speck of red at the top of the hill stirred my interest. It was a courageous horse named Carablanca, an Iberian import that has toiled the land for centuries.

Uphill and down, row after row, this workhorse carved the earth. When plow hit stone, Carablanca stalled at the anchored rock. The horse caught its breath, regained its footing, and continued along the millennial path that is too well known to man and beast.

Since childhood I have loved horses, and Carablanca was no exception. I could sense the horse's strength as he pulled the weight of the plow, the exhaustion in the white stare of his eyes.

Echoes of the horse's neighing triggered a challenge for me fueled by pure adrenalin. My climb to the top of the hill was strenuous, but the majestic view made it worthwhile. I could now see that there were two horses, not one. They were being driven by a father-and-son team—a master and his young,

unwilling apprentice. How often the sweat of one's brow is inherited and not chosen.

I've been a photographer many years, and I am still overwhelmed by a feeling of great respect for my subjects. Sometimes they welcome me into their world with blind trust, and other times they turn me away.

I began to take photographs amid this beautiful backdrop. I scrambled to keep up with the horses and their humans, to frame, compose, catch my breath—and defend myself from the painful stabs of the agave. I struggled to keep up, but finally my shoes were destroyed, hopelessly damaged by a single morning trekking with people who were born into a life so distant from mine. I watched the horse strain each time the plow hit stone, yet both man and beast continued the task of the hour, of the day, of a lifetime.

Later in the day, my aching back forced me to plunk down onto the floor. The cool tile provided relief from the heat of the afternoon. I glanced to my left and saw Rafael, a semiretired jimador. He sat in silence. His face reminded me of a long-lost cousin on my father's side. The feeling of family was immediate. As I sat up, I noticed that the jimador had a stack of *hijuelos*, agave pups.

I couldn't resist asking if I could take his portrait. With a pronounced shyness, he agreed. I looked around and quickly found a space with lovely reflective soft light and an adobe wall as a backdrop. I asked Rafael to follow me with his hijuelos.

As I framed the image, I was struck by his stoic pose, the honest confession of a hard life. Cousin or not, Rafael felt like a brother, or like that childhood friend who gets lost in time and years later reappears as an old man. For that brief moment we were family.

EL ASCENSO 🌾 THE ASCENT

Tequila, Jalisco

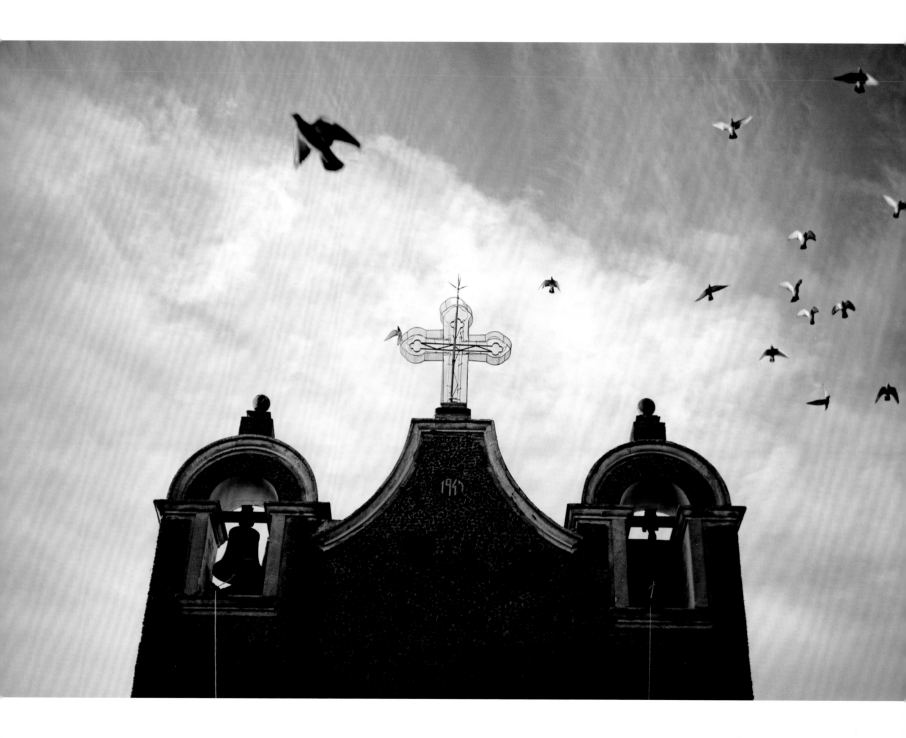

EL SEÑOR DEL FUEGO ❧ LORD OF FIRE

Tequila, Jalisco

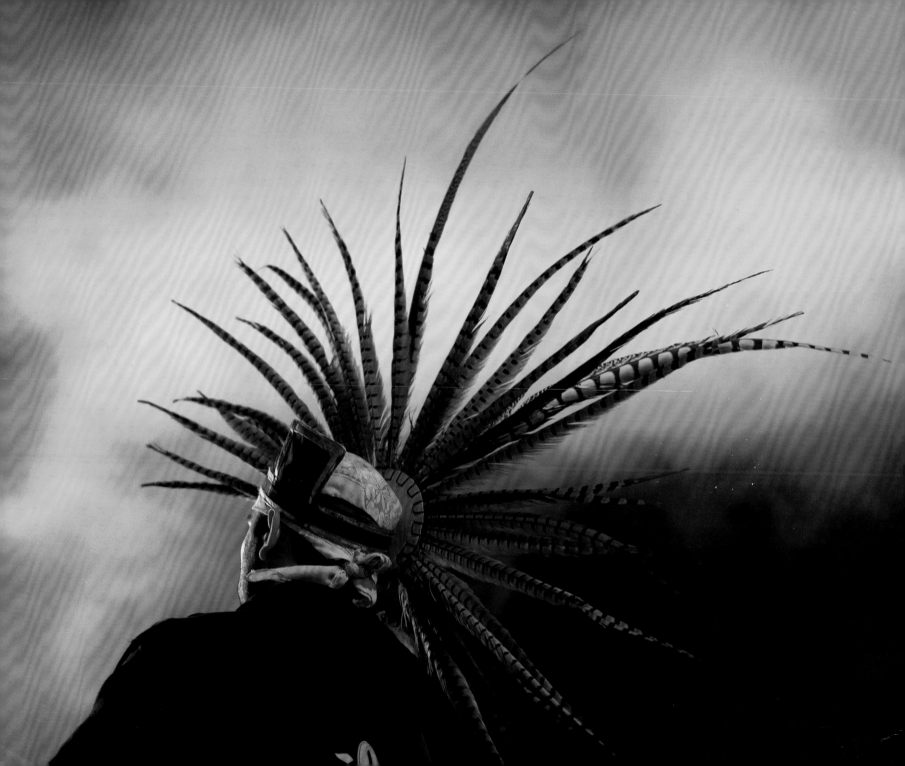

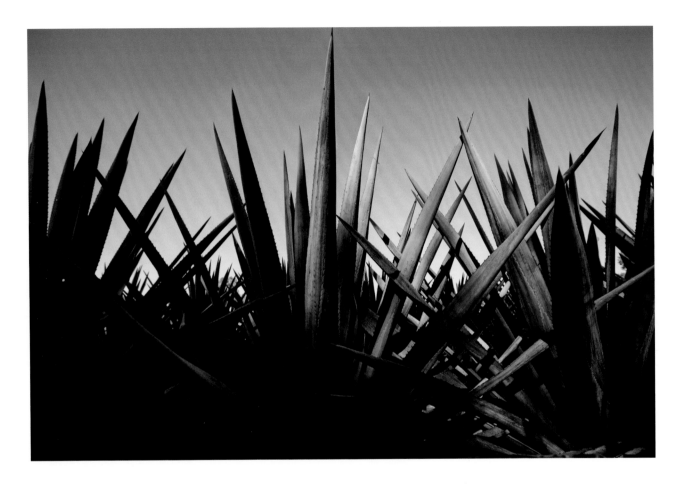

AGAVE AZUL ⚜ BLUE AGAVE

Arandas, Jalisco

HIGHLANDS OF JALISCO

Atotonilco el Alto, Jalisco

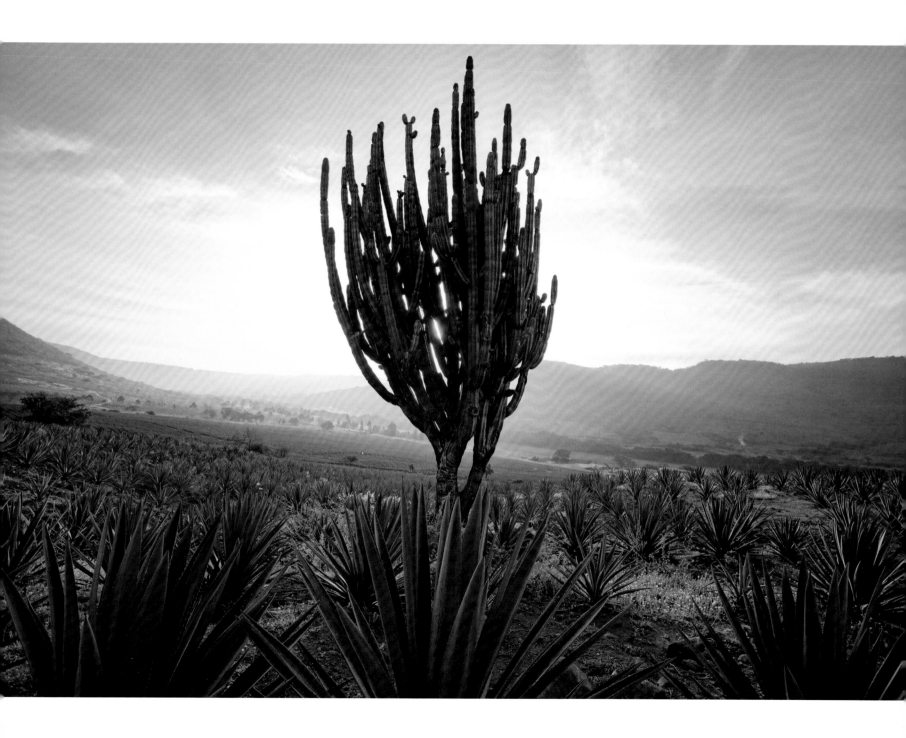

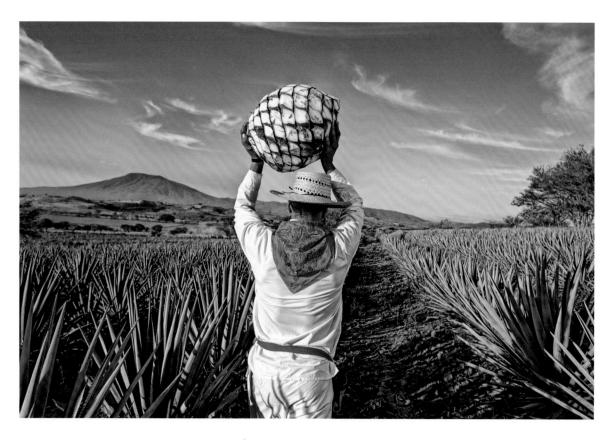

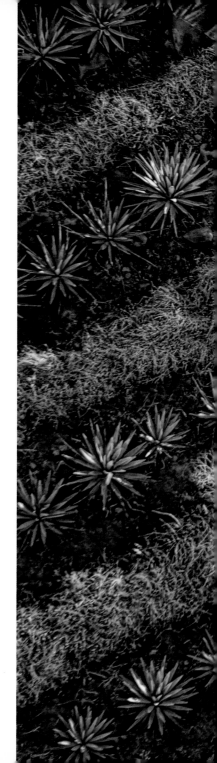

CORAZÓN DE AGAVE ⸱ AGAVE HEART

Tequila, Jalisco

LOS CAMPOS DE AMATITÁN ⸱ FIELDS OF AMATITÁN

Amatitán, Jalisco

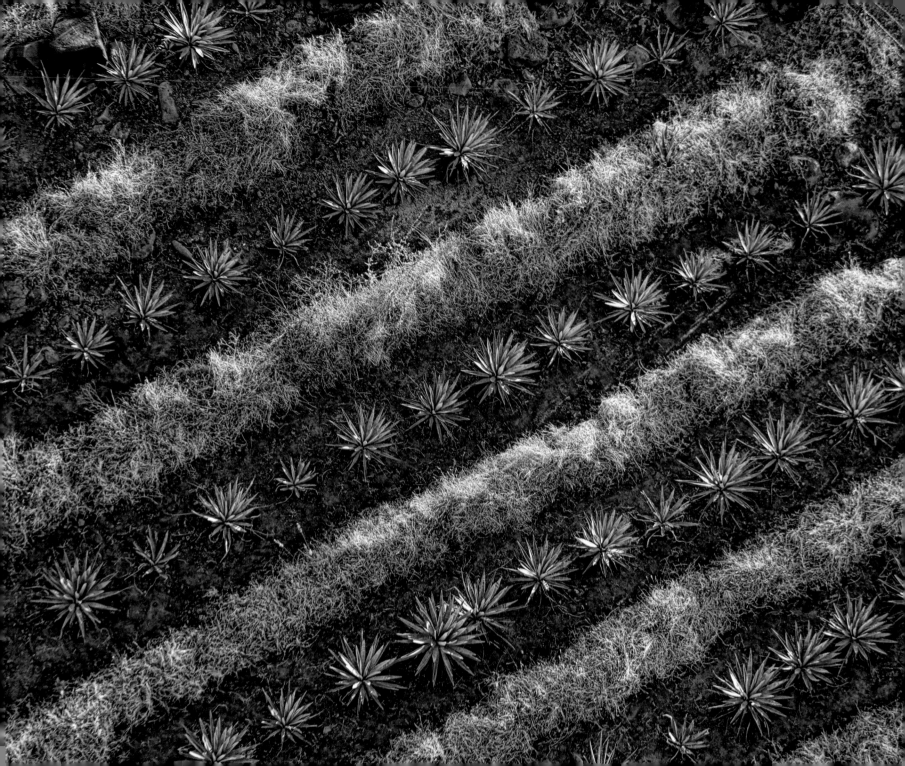

EL JIMADOR CON HIJUELOS ❁ HARVESTER WITH AGAVE SPROUTS

El Arenal, Jalisco

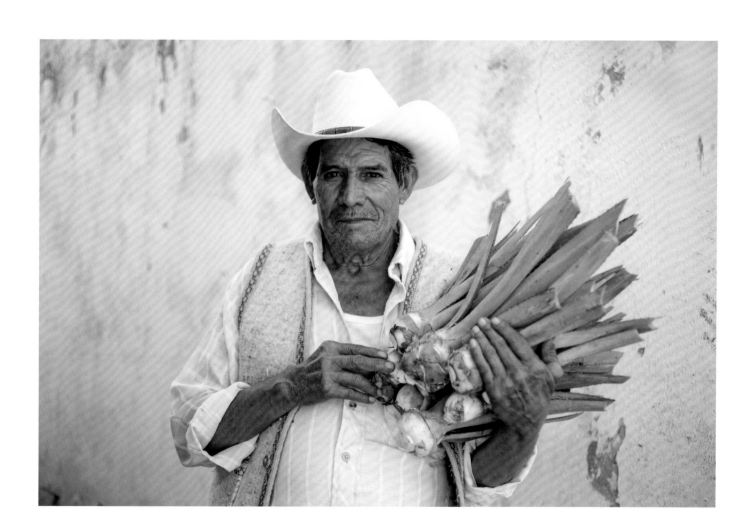

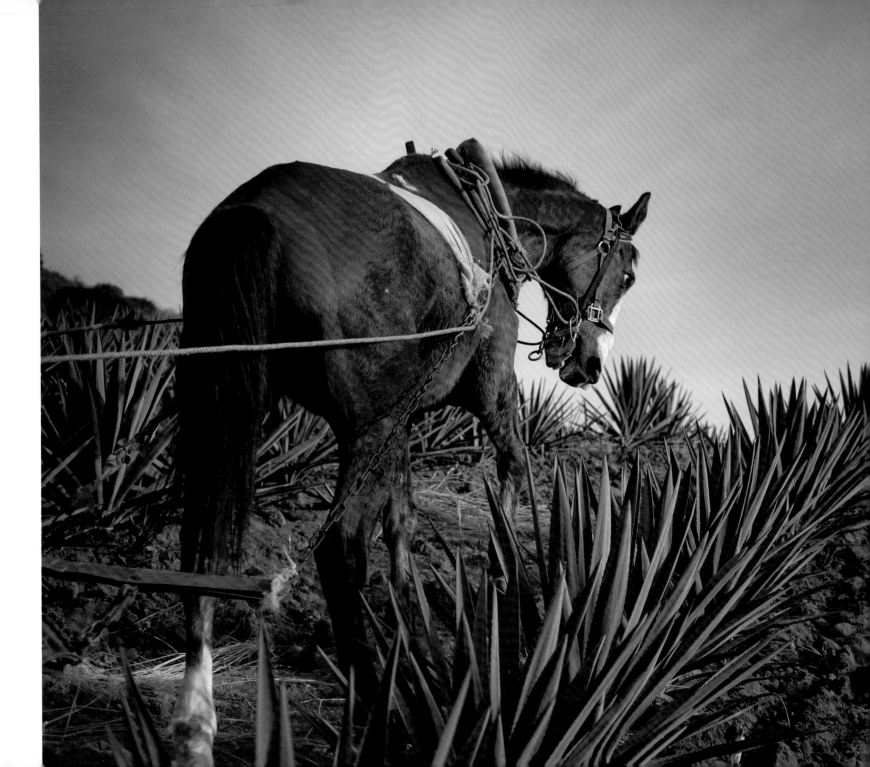

LA LABRANZA ⁂ THE TILLING

Atotonilco el Alto, Jalisco

ANTE EL ALTAR ❧ **BEFORE THE ALTAR**

Amatitán, Jalisco

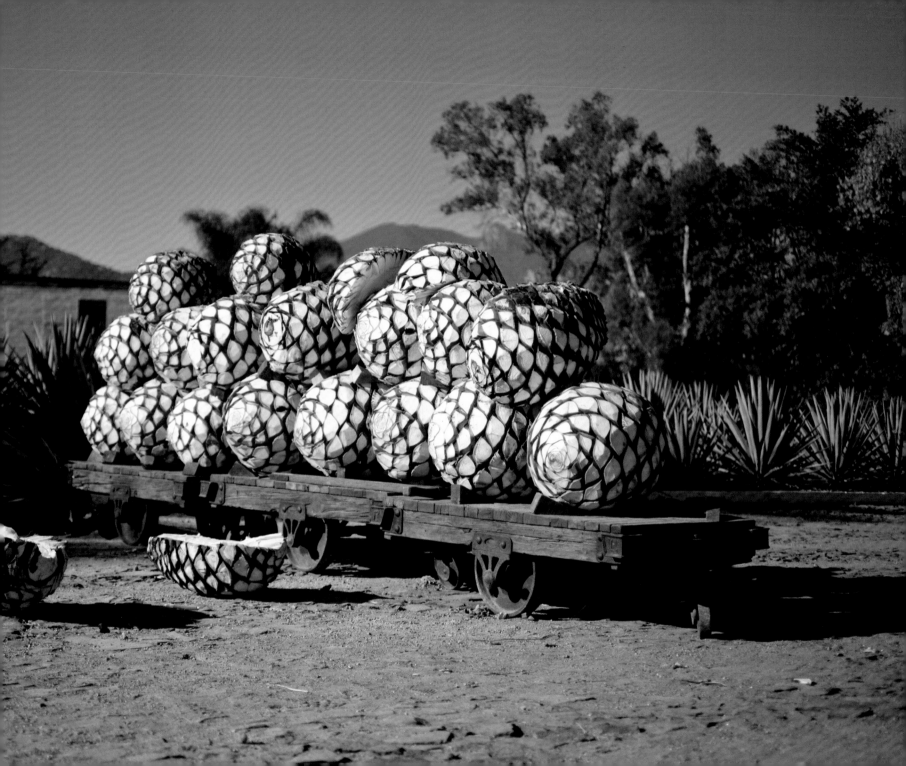

The jimadores are resilient men traversing spiny fields of blue, thrusting their coa tools into magnificent agave to slice off a crown of daggers. They reveal the sacred heart of Mayahuel, the agave queen of the Aztecs. They are the centurions of tequila and guardians of a ritual born of earth, sky, and fire—a constant harvest, day in and day out.

By the lunch hour, the jimadores had laid thin steaks on a comal—an iron griddle—and were savoring their tacos with the pleasure that comes from eating in the company of Mother Nature.

Hours earlier, six agave *piñas*, or cores, had been sacrificed and arranged to make a circular fire. As the tentacles from the fire began to reach for the skyline, I thought about how much the jimadores were enjoying their hard-earned meal.

When the sun finally dipped below the horizon, I wondered who, from the land of Jalisco, was the first to build this agave fire? Was this ovenlike innovation the accidental origin of mezcal and tequila, or did the lightning described in indigenous folklore strike the ancient wild agave of the Aztecs and release its sweetness into the world?

The piña of the blue agave takes eight to ten years to reach its harvesting prime.

A jimador might explain that the male agave develops a *cogollo*, a waxy accumulation of dwarfed leaves that must be removed before the roasting process. Agave syrup can become bitter if the cogollo is not removed. The female agave core will eventually send up a stalk known as a *quiote* that blooms when it reaches maturity, after ten to twelve years. Once in bloom, cross-pollination occurs with assistance of bats, potentially giving life to new agaves. Growers normally do not allow cross-pollination to occur, relying instead on the *hijuelos*, pup sprouts that emerge from the root system. The hijuelos are harvested and replanted to continue the cycle.

TIERRA, ESPINA, Y AGAVE ❦ TERRA, THORN, AND AGAVE

Arandas, Jalisco

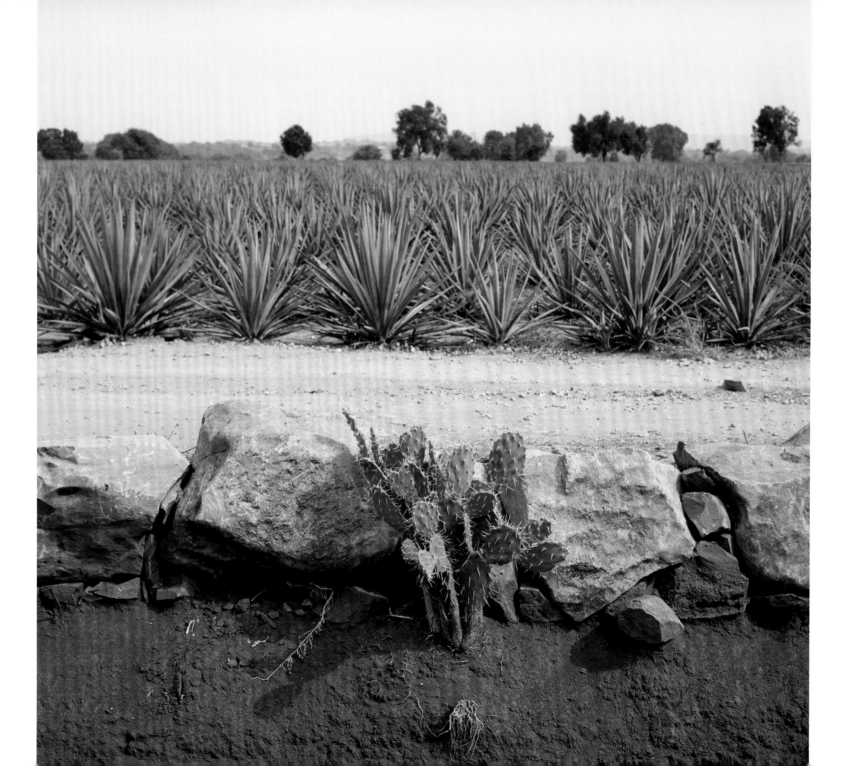

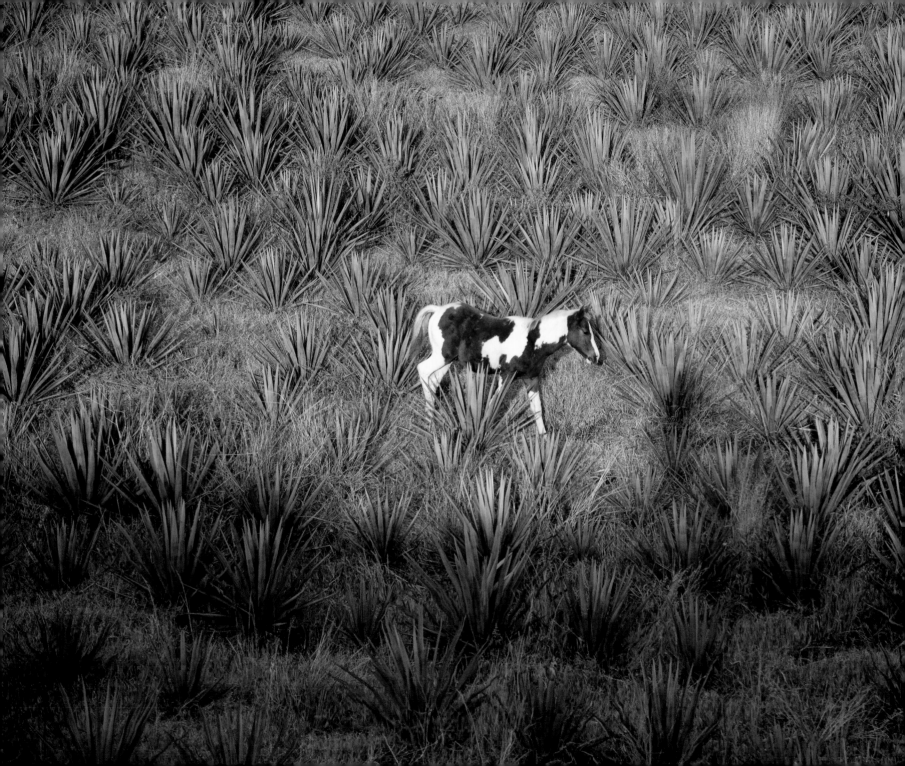

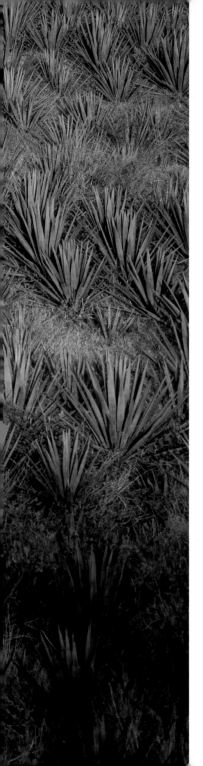

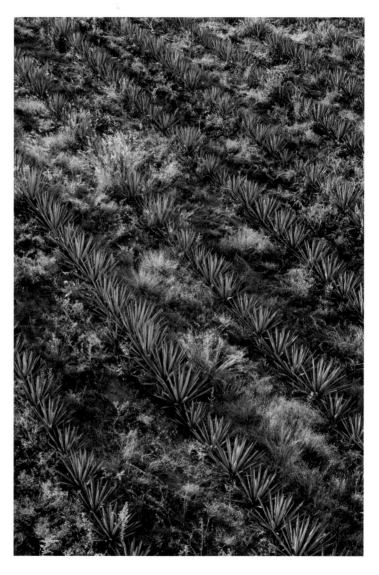

TEQUILANA AZUL ⸭ **BLUE TEQUILANA**

Amatitán, Jalisco

EL CABALLITO AGAVERO ⸭ **AGAVE COLT**

El Arenal, Jalisco

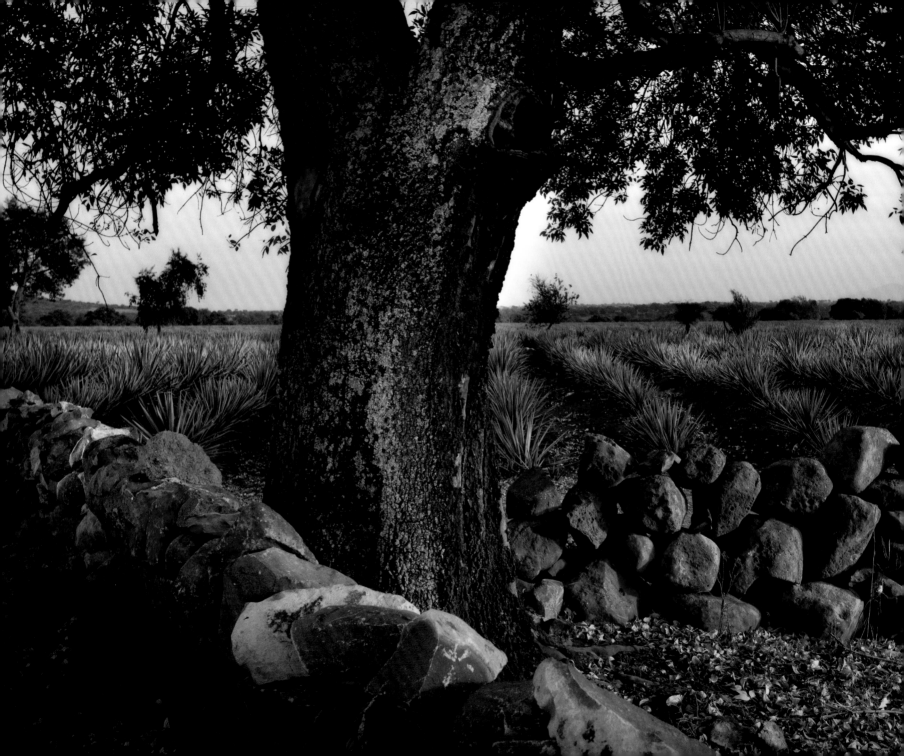

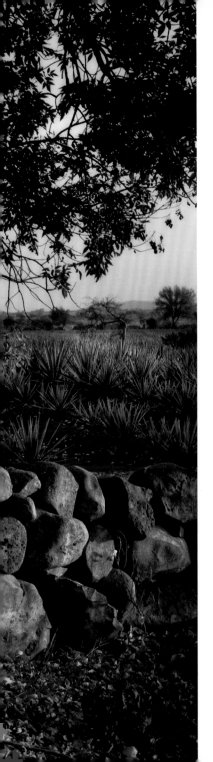

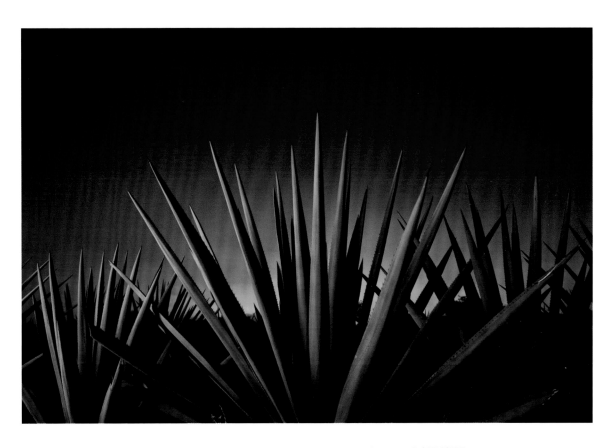

AGAVE AZUL AL ATARDECER ॐ BLUE AGAVE AT SUNSET

Tequila, Jalisco

EL CAMPO AZUL ॐ BLUE FIELD

Arandas, Jalisco

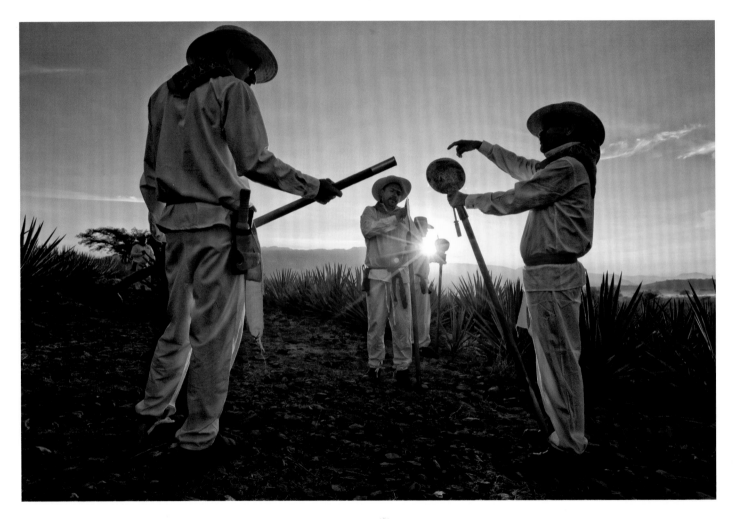

LOS JIMADORES AL AMANECER ❧ HARVESTERS AT SUNRISE

Tequila, Jalisco

LAS SOMBRAS EMPEDRADAS ✳ COBBLESTONED SHADOWS

Arandas, Jalisco

On the road to Chome, Jalisco

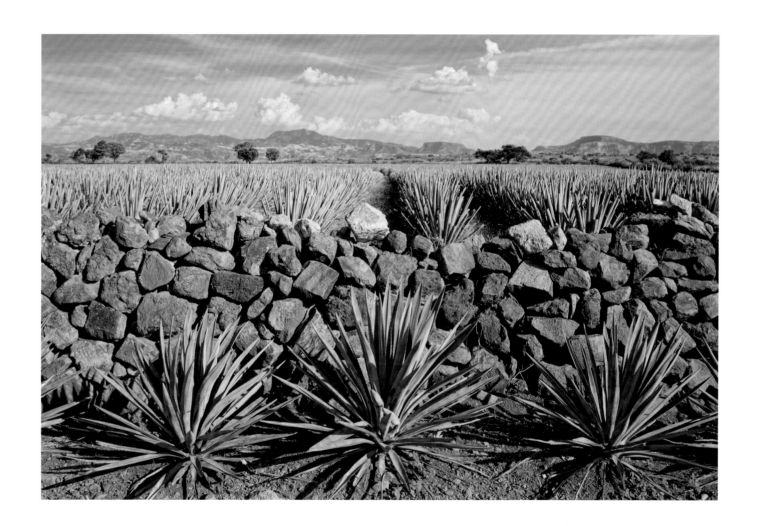

EL JIMADOR THE HARVESTER

La Barca, Jalisco

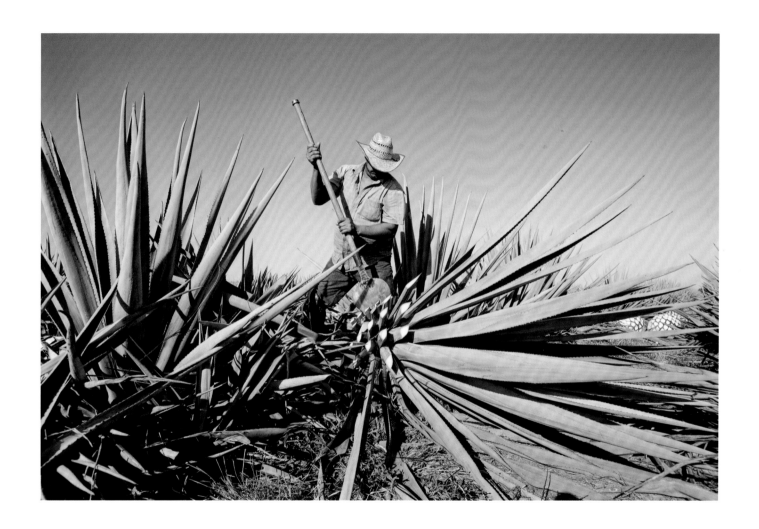

EL AFILADOR ✿ THE GRINDER

Amatitán, Jalisco

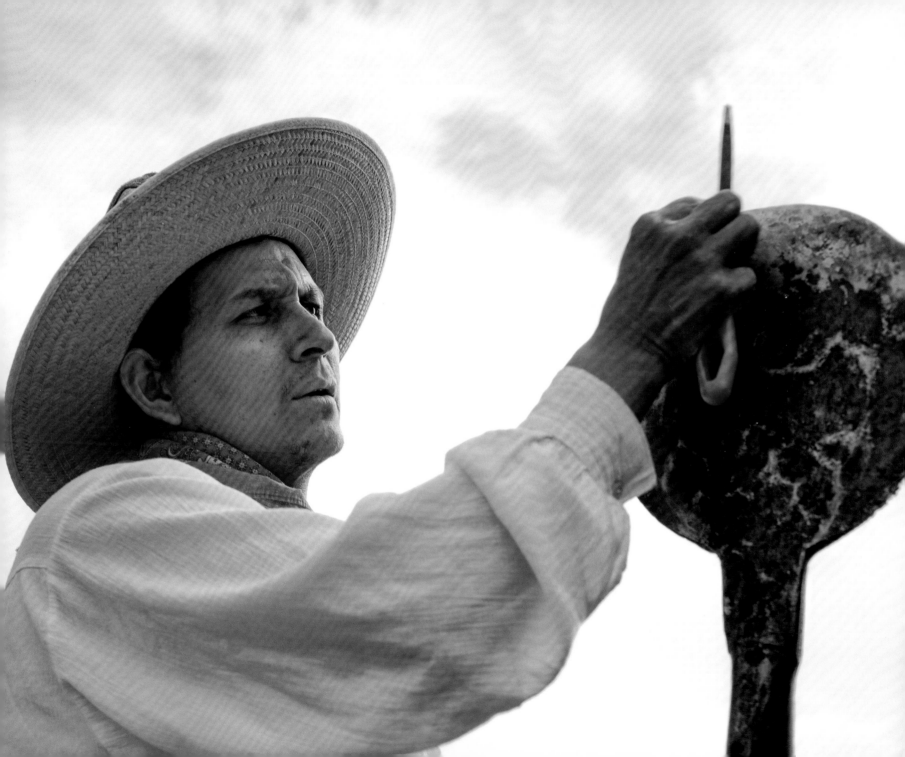

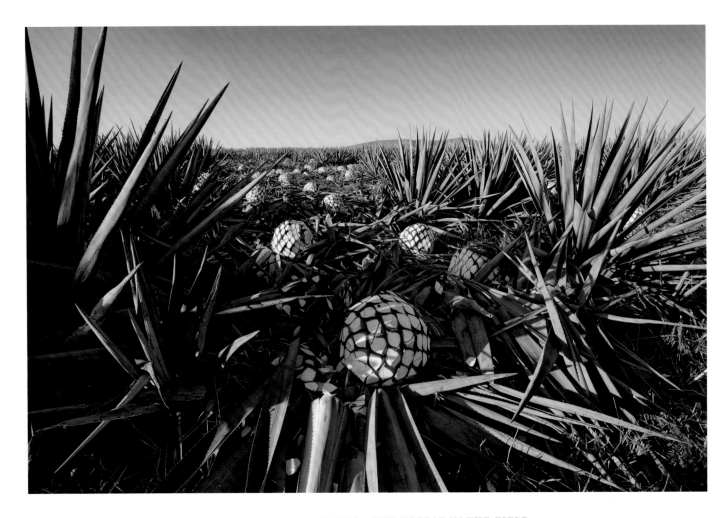

LA DERROTA EN EL CAMPO ❧ **THE DEFEAT IN THE FIELD**

La Barca, Jalisco

EL GUARDIÁN DE LOS AGAVES ❧ **GUARDIAN OF THE AGAVES**

Arandas, Jalisco

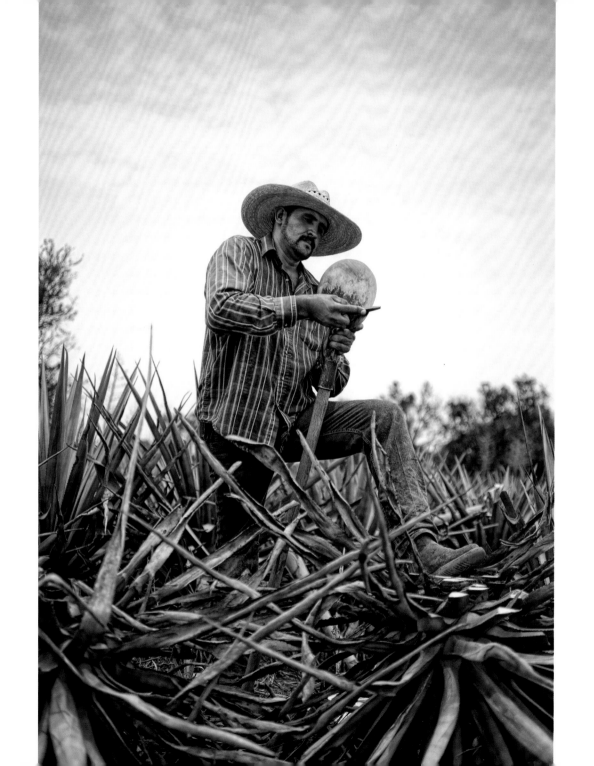

EN REPOSO ✦ AT REST

La Barca, Jalisco

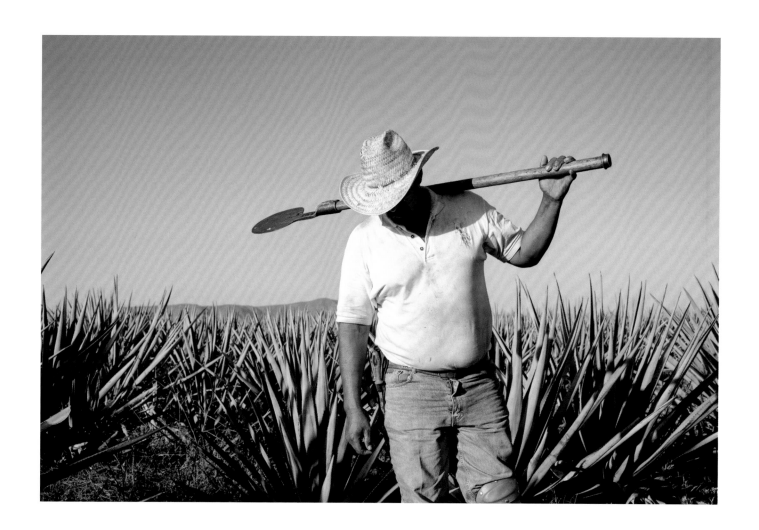

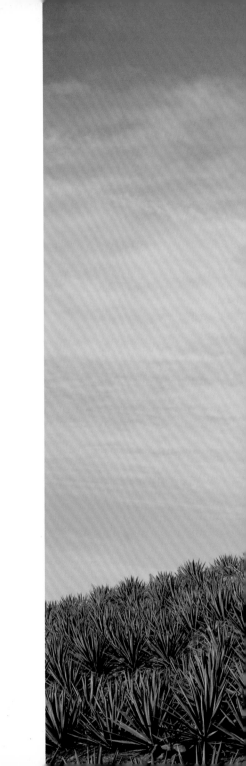

EL ARBOLITO AGAVERO ✿ LITTLE TREE OF THE AGAVES

Atotonilco el Alto, Jalisco

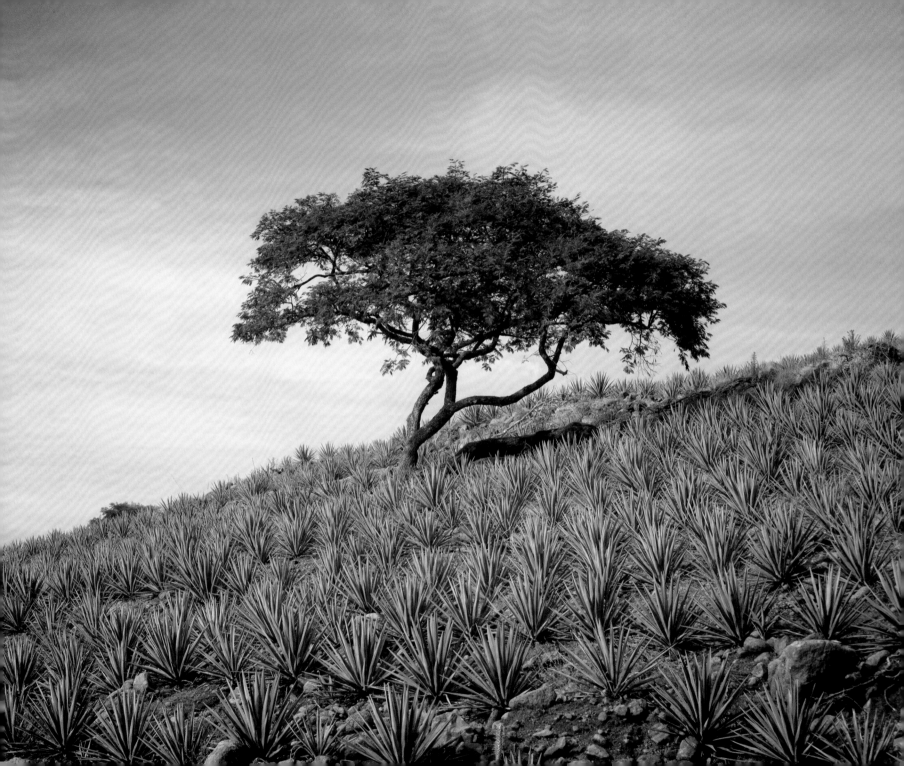

AGAVE AZUL 🌿 BLUE AGAVE

La Barca, Jalisco

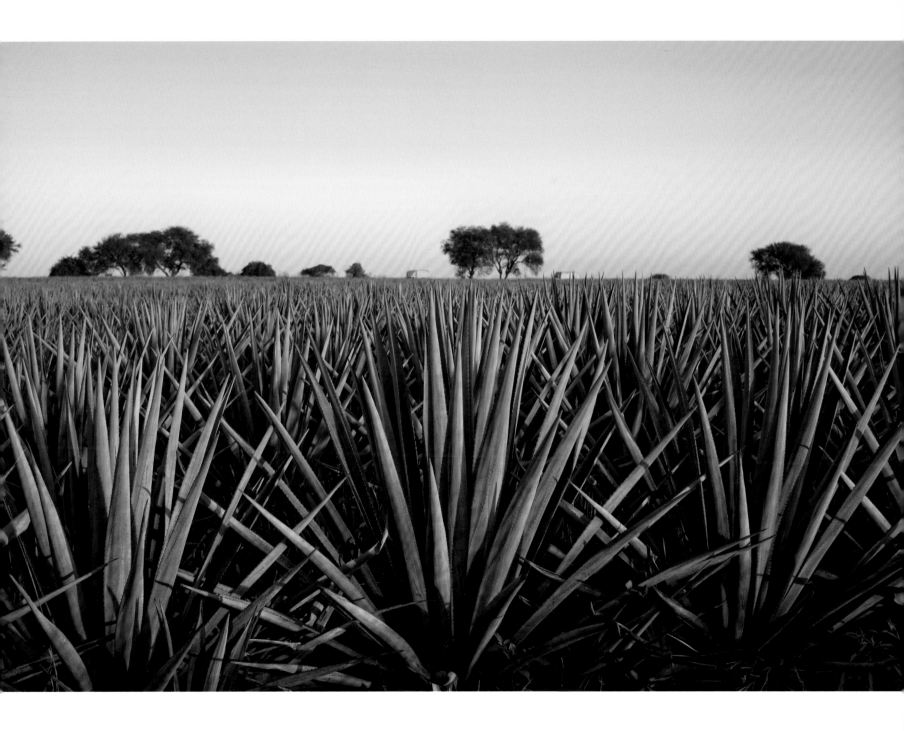

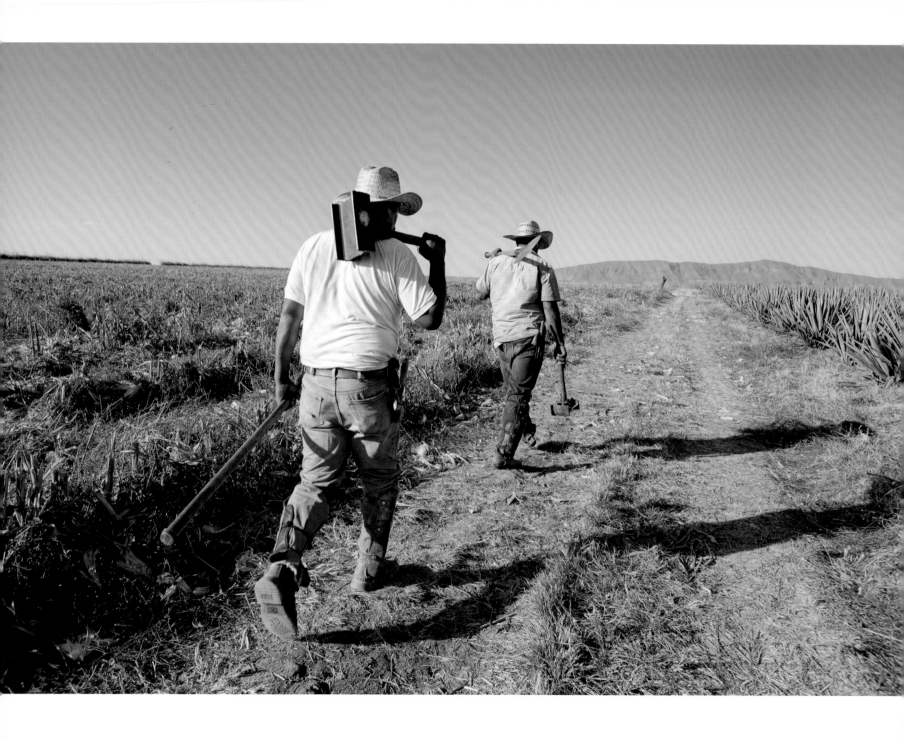

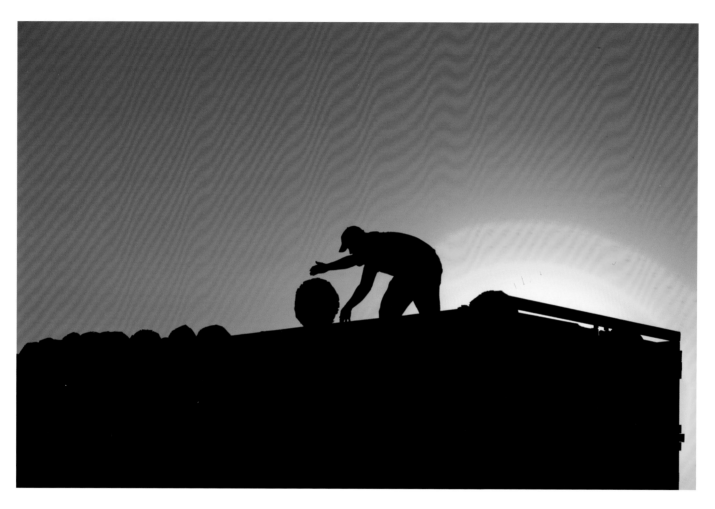

EL ATARDECER ⇒ DUSK

La Barca, Jalisco

LOS CAMINANTES ⇒ THE WAYFARERS

La Barca, Jalisco

FUEGO CON FUEGO ✺ **FIRE WITH FIRE**

La Barca, Jalisco

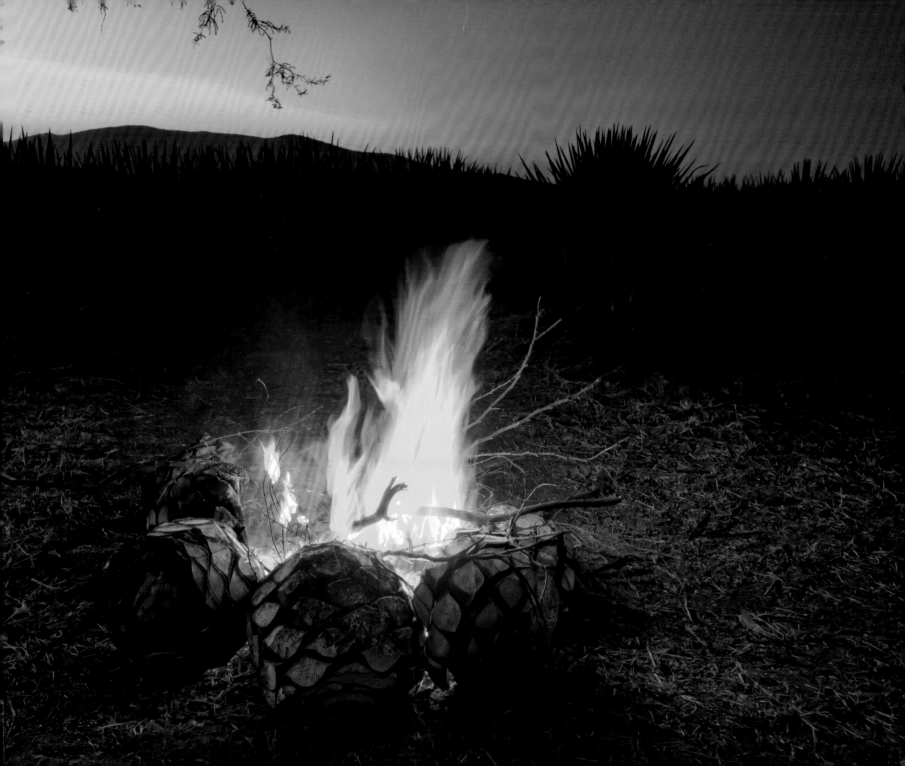

ucked in the corner of modern Mexican history is La Cristiada, the Cristero Rebellion, a three-year struggle in the late 1920s primarily aimed at the separation of church and state.

The president at the time, Plutarco Elías Calles, wanted to eliminate the Catholic Church's influence in the country, born out of the anticlerical articles of the Mexican Constitution of 1917. Given Mexicans' popular allegiance to Catholicism, a massive armed uprising ensued.

During those challenging years many Cristero soldiers took refuge in the cavernous tequila distilleries, where tunnels hid the persecuted and allowed their escape to safer ground. In some cases these dark tunnels now serve as perfect aging bodegas for that blessed elixir called tequila.

It is said that tequila fueled the Mexican Revolution of 1910—a symbolic protest by indigenous foot soldiers and revolutionaries against the cognac and brandy of the elite. It wasn't until the 1950s, at the peak of the Golden Age of Cinema, that Mexicans truly became enamored with their national drink, watching their movie idols project machismo and tequila on the big screen.

Tequila Sauza was the first distillery to export tequila to the United States in 1873, when three barrels passed through El Paso del Norte, present-day El Paso, Texas. Today the United States purchases more tequila than Mexico, and the spirit is so popular around the world that 80 percent of the product is exported.

Tequila has undeniably become Mexico's great ambassador to the world.

The craft of making tequila requires many tools, among them the tahona. The Arabs named it, the Spaniards brought it to Mexico, and today the most demanding of tequileros won't make tequila without it. The tahona is composed of an enormous grindstone wheel, usually made of volcanic rock and set in a pit, that mashes the succulent pulp of cooked agave piñas.

Traditionally driven by a horse or mule, most tahonas are now pulled by a tractor or other motorized device. Unlike mechanized mashing processes, the massive weight of the stone crushes every fiber of the agave heart, extracting tastes and aromas rooted deep in the rough strands.

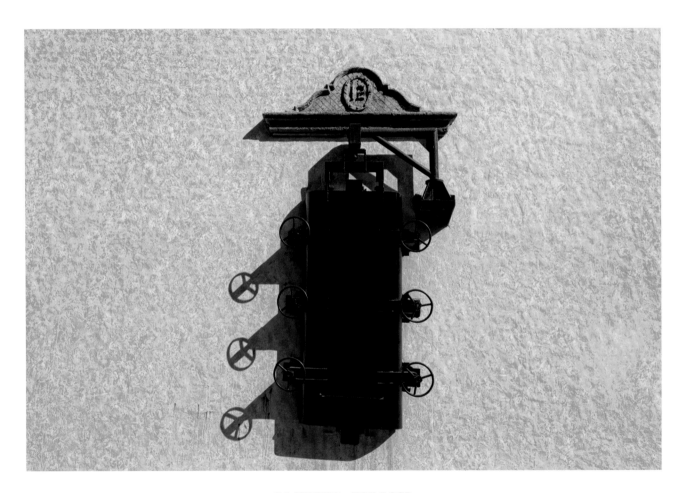

LA PUERTA ❧ **THE DOOR**

Tequila, Jalisco

EL OBRERO ❧ **THE WORKER**

Tequila, Jalisco

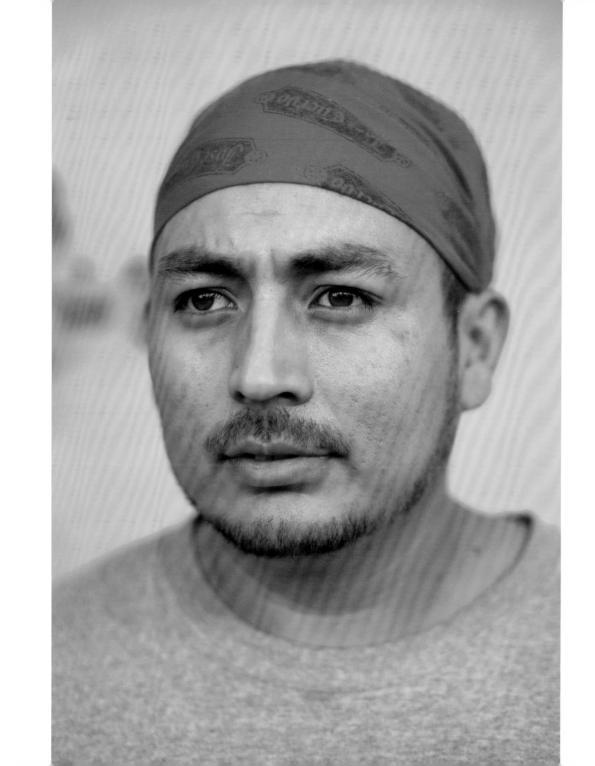

LOS HACHEROS 🌿 THE AX-MEN

Tequila, Jalisco

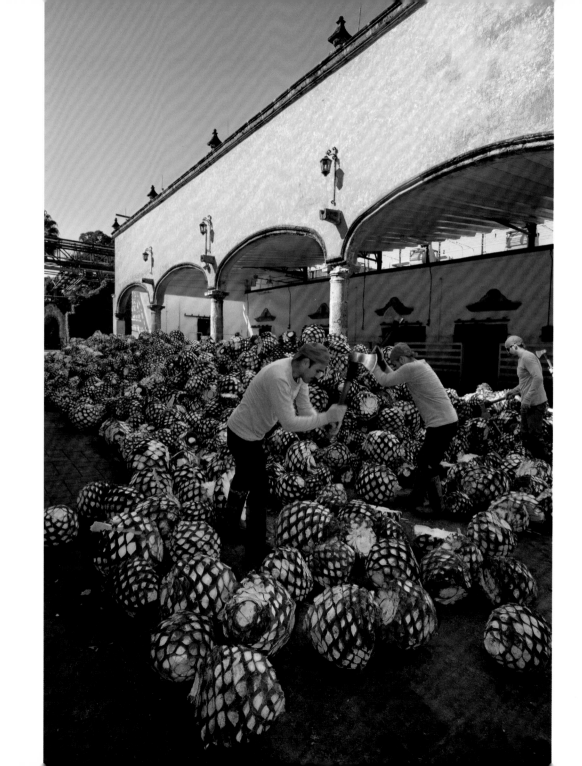

SEMILLAS DE AGAVE AZUL ❋ BLUE AGAVE SEEDS

El Arenal, Jalisco

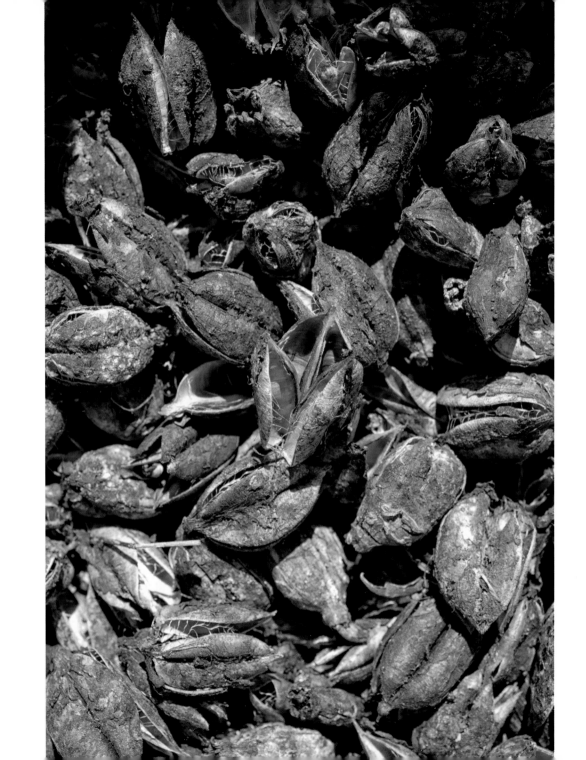

EL MEXICANO ✻ THE MEXICAN

Amatitán, Jalisco

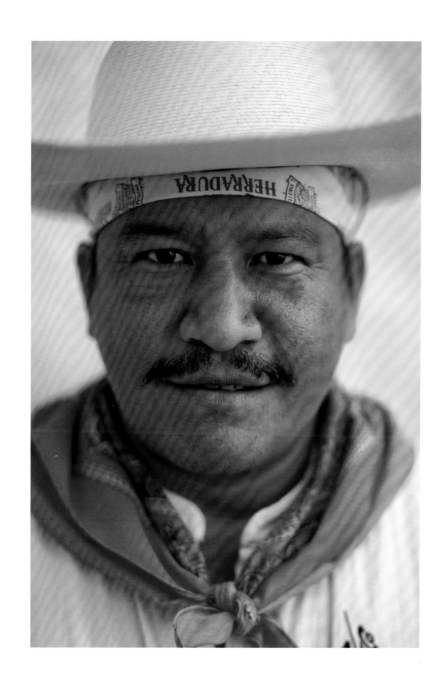

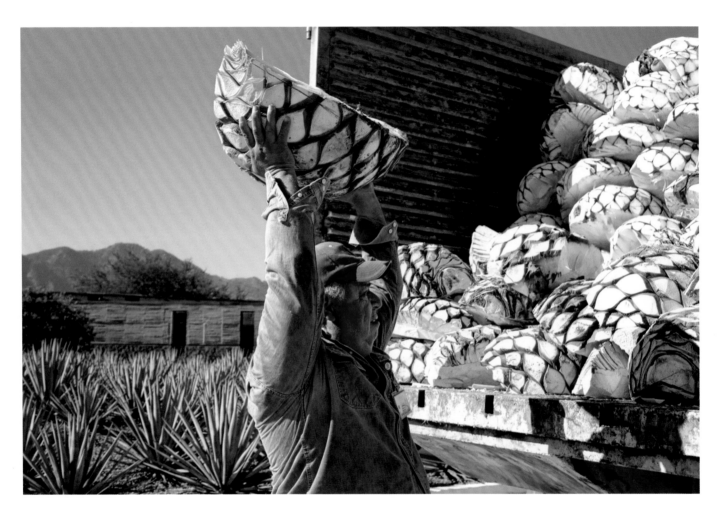

AGAVE EN ALTO ⸰ **RAISED AGAVE**

Amatitán, Jalisco

LA CARGA ⸰ **THE LOAD**

Arandas, Jalisco

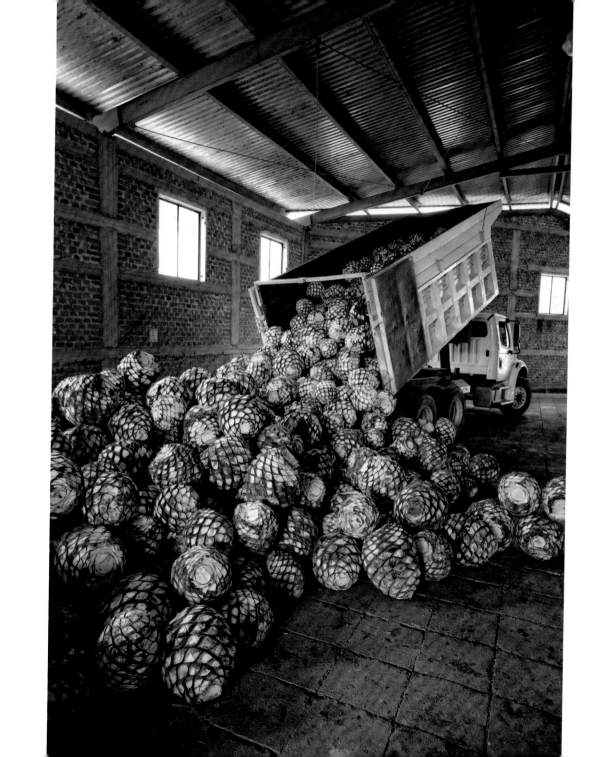

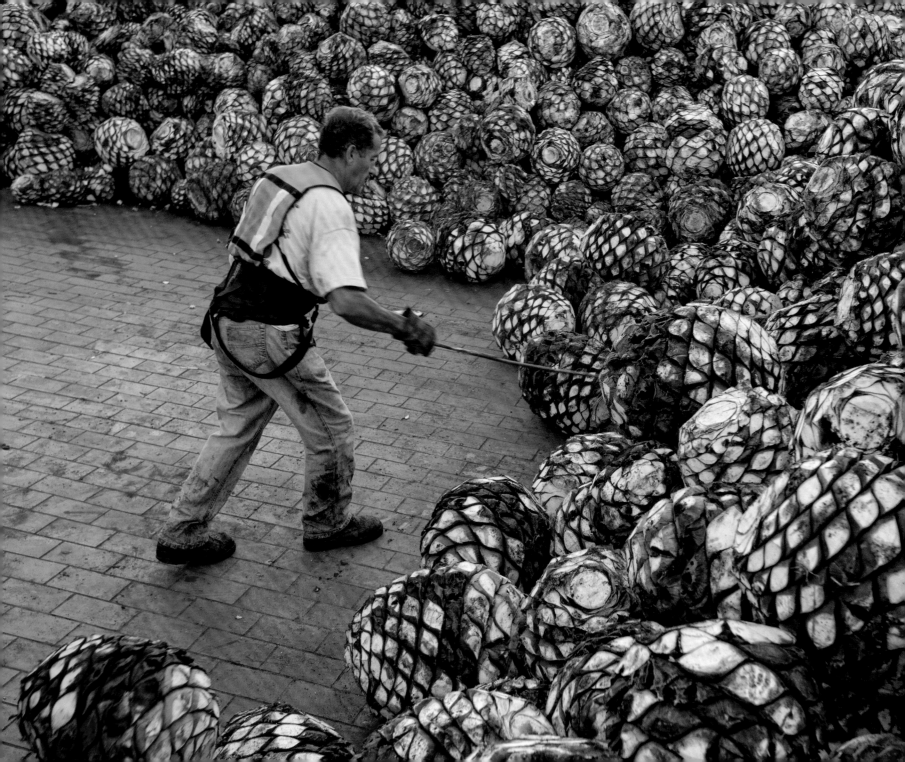

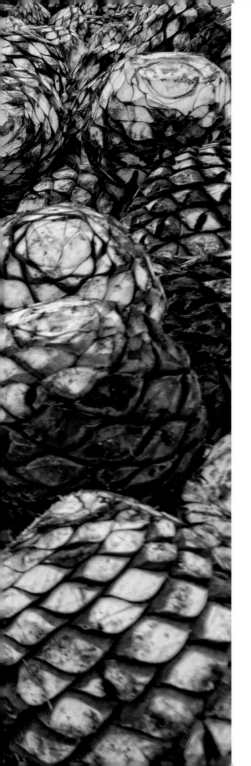

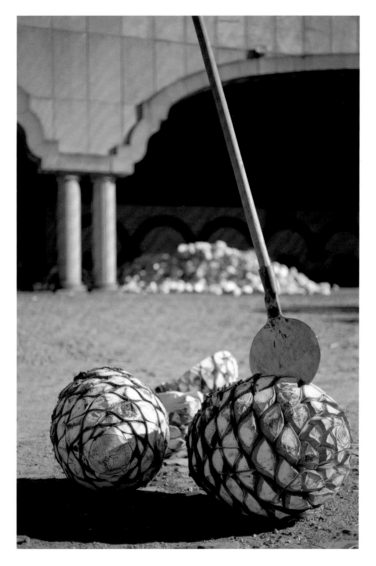

COA Y AGAVE ⬩ COA TOOL AND AGAVE

Amatitán, Jalisco

EL PICADOR ⬩ THE PICKER

Atotonilco el Alto, Jalisco

LA ESCALERA THE LADDER

Arandas, Jalisco

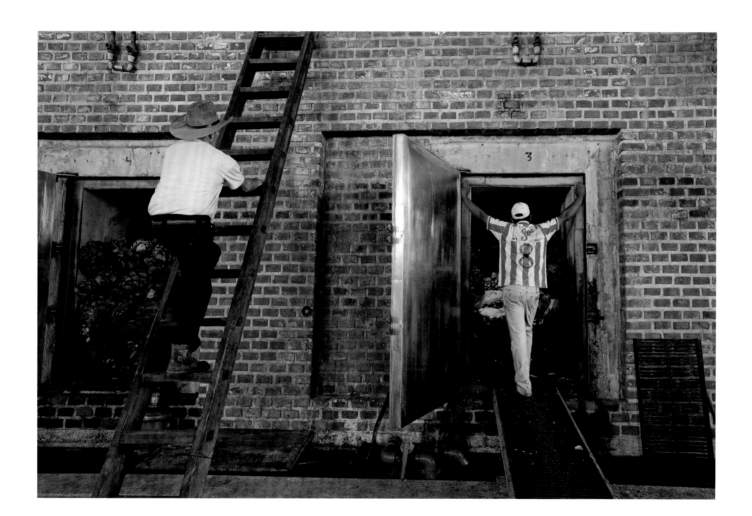

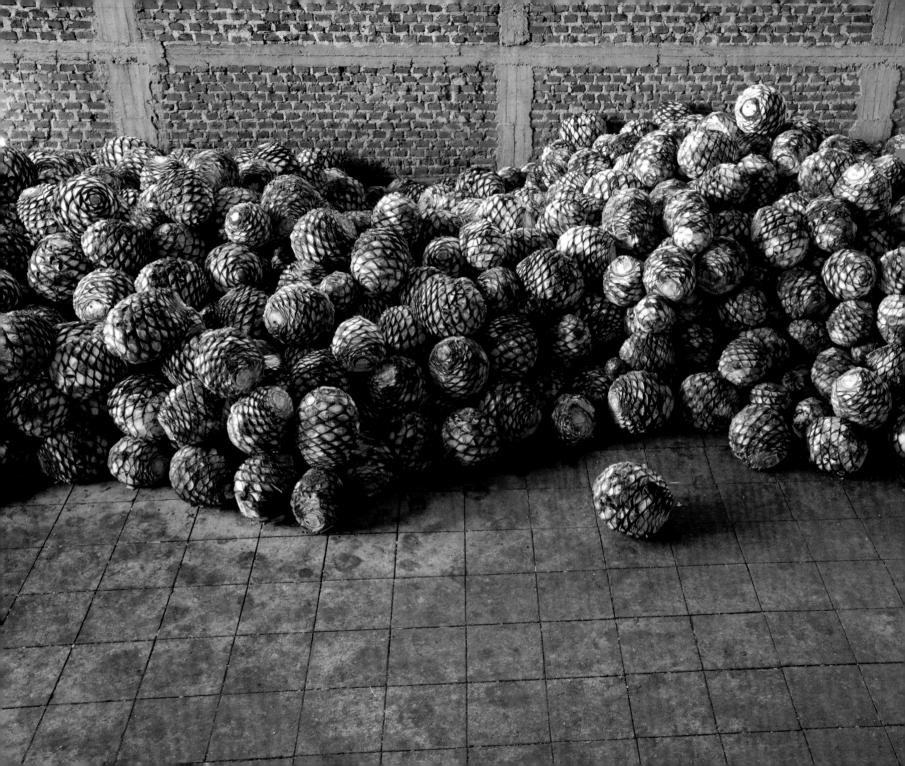

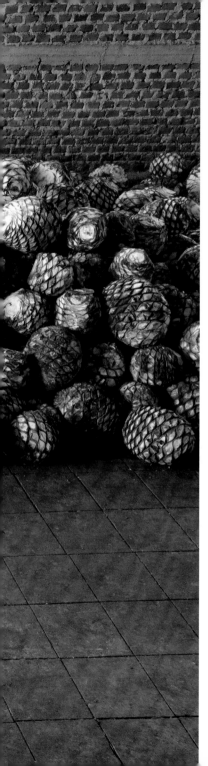

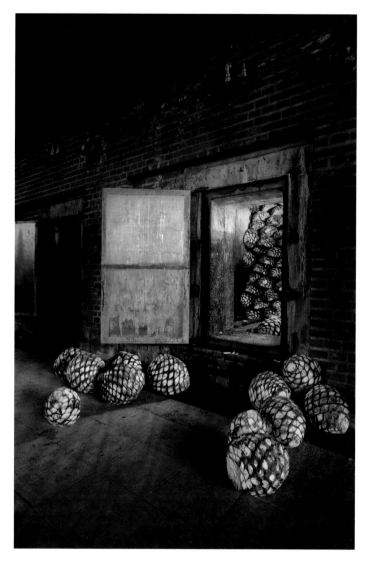

HORNO A LA ESPERA ᛃ WAITING OVEN

Arandas, Jalisco

EL MURO DE AGAVE ᛃ AGAVE WALL

Arandas, Jalisco

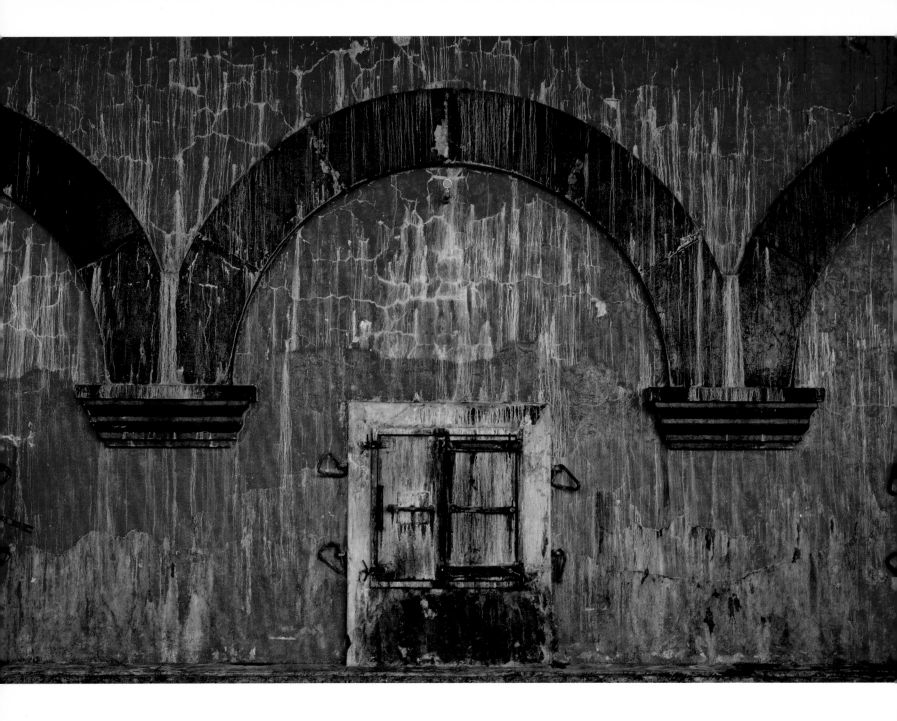

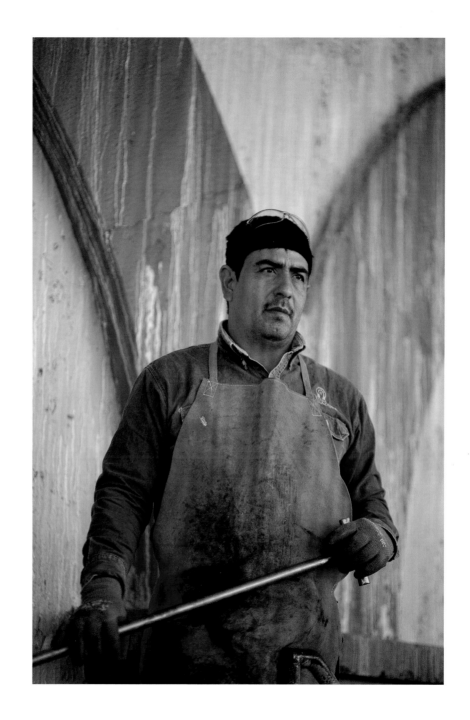

EL GUÍA ⸱ THE GUIDE
Amatitán, Jalisco

HORNO CERRADO ⸱ CLOSED OVEN
Amatitán, Jalisco

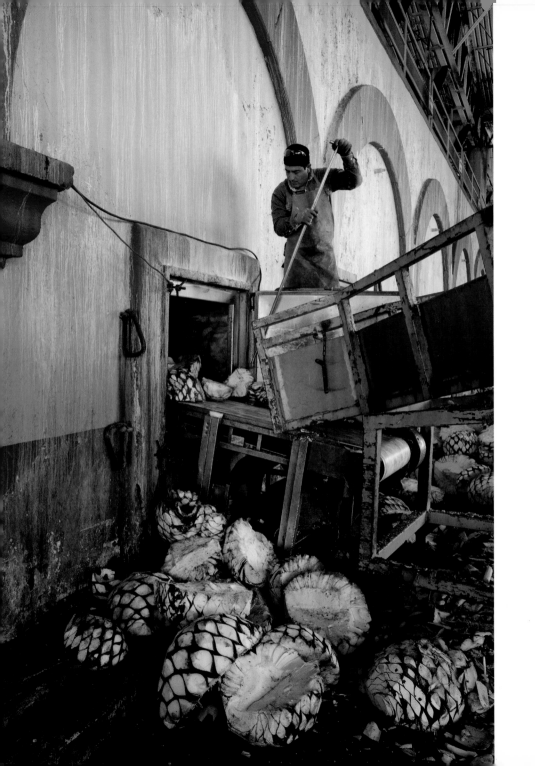

EL CARGADOR DE AGAVE ᵒ THE AGAVE LOADER
Amatitán, Jalisco

LA ODA AL HORNO ᵒ ODE TO THE OVEN
Amatitán, Jalisco

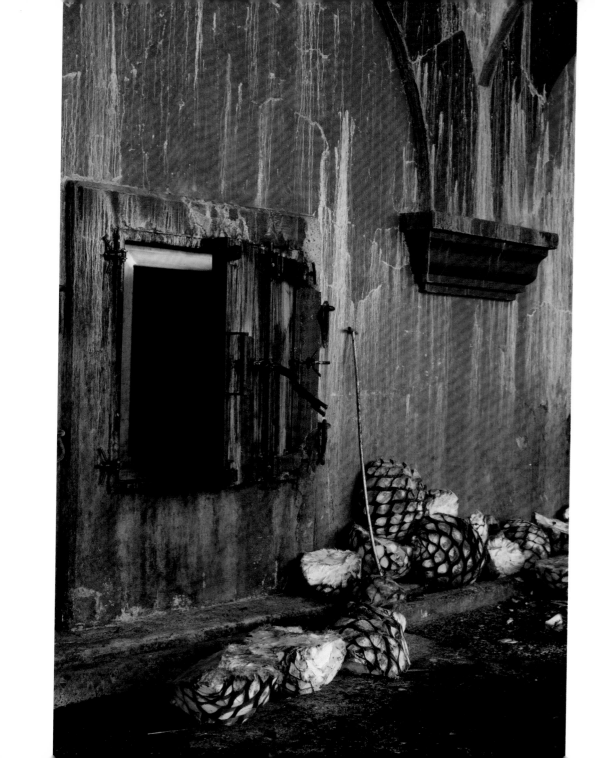

EL LEGADO 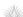 THE LEGACY

Amatitán, Jalisco

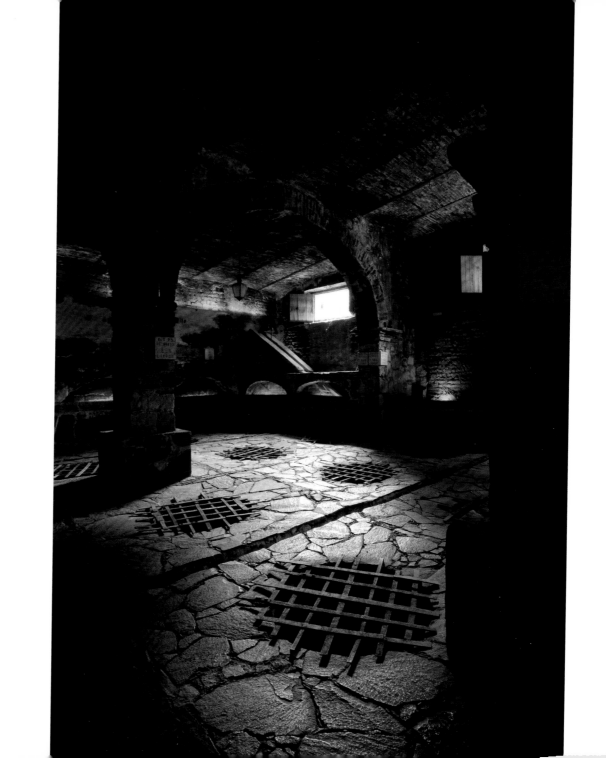

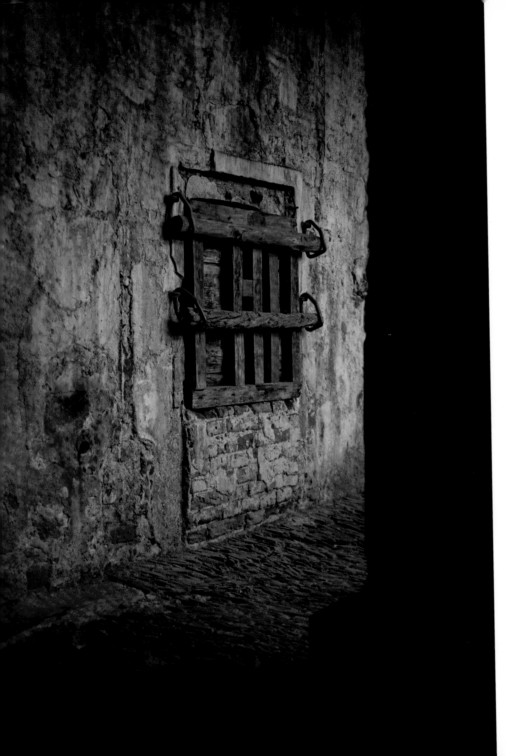

LA PUERTA AL PASADO ⁊ DOOR TO THE PAST

Amatitán, Jalisco

※

EL ALAMBIQUE DE COBRE ⁊ COPPER STILL

Amatitán, Jalisco

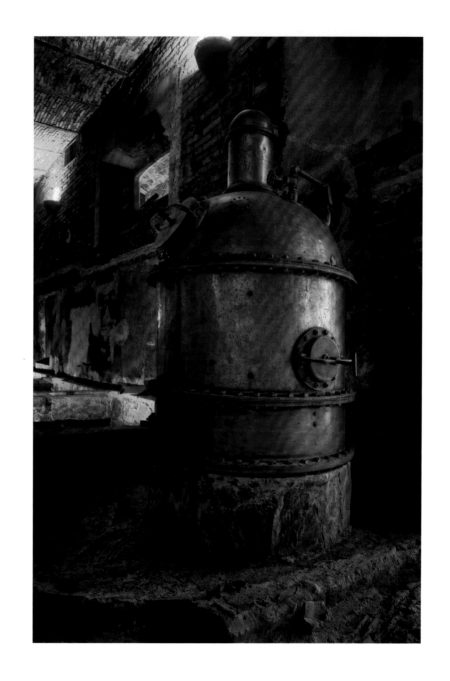

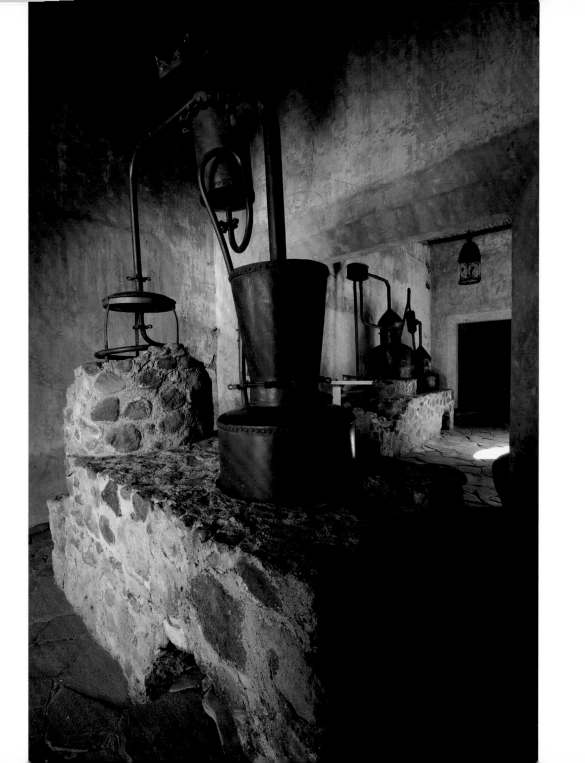

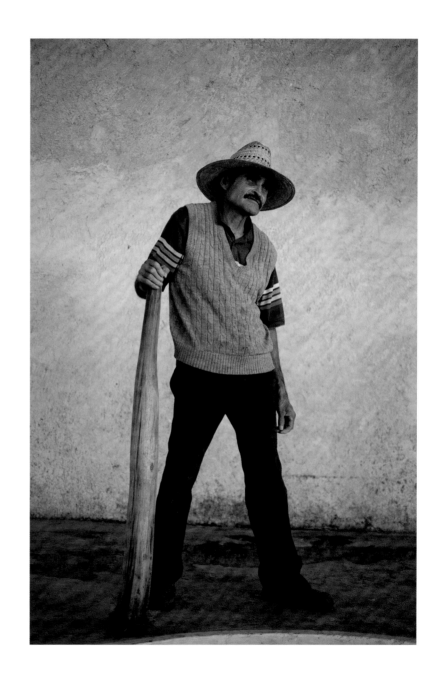

EL SIGLO XVIII ❧ EIGHTEENTH CENTURY

Tequila, Jalisco

HOMBRE CON MAZO ❧ MAN WITH MALLET

El Arenal, Jalisco

LA CUCHILLA DE LUZ ※ DAGGER OF LIGHT

El Arenal, Jalisco

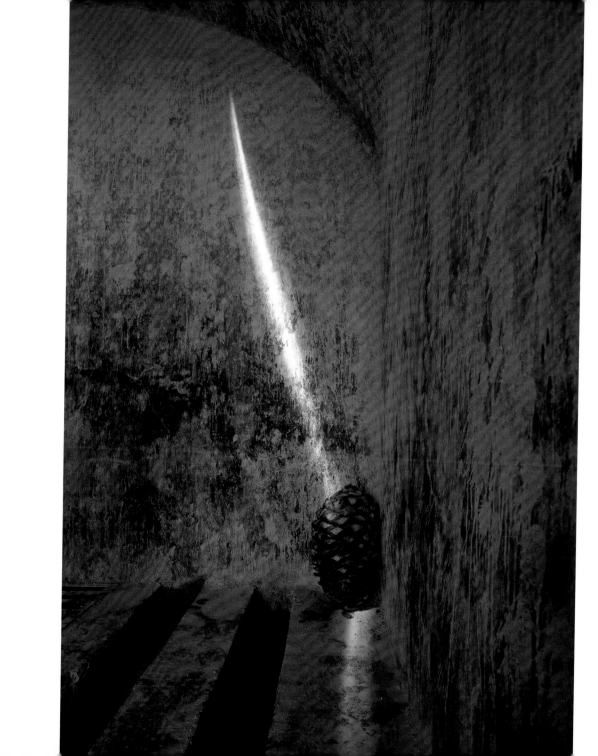

AGAVE DULCE SWEET AGAVE
Arandas, Jalisco

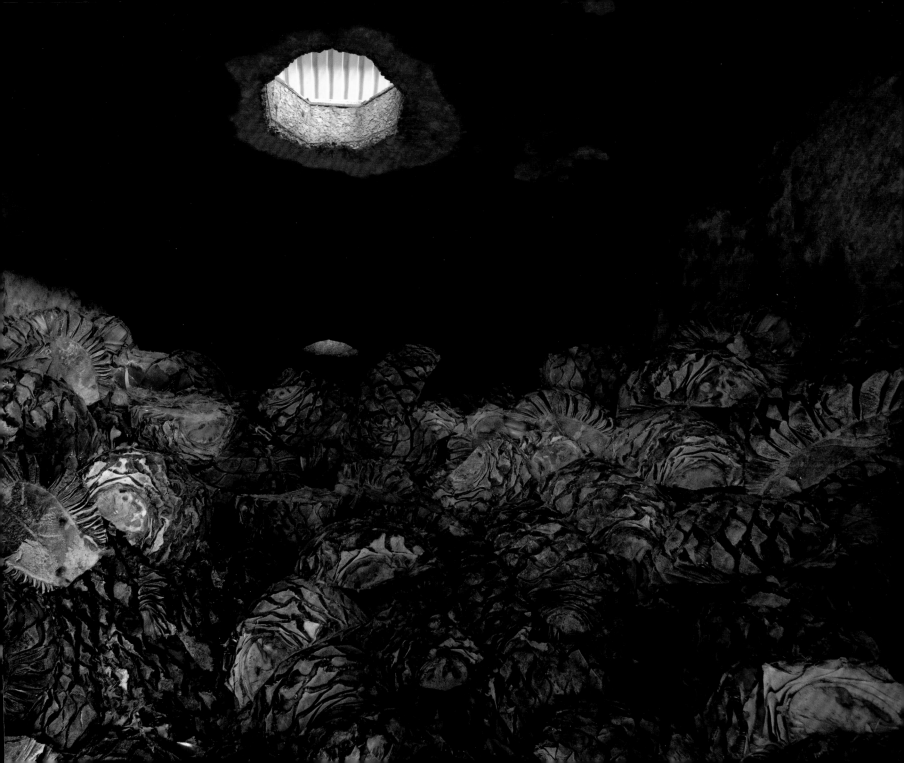

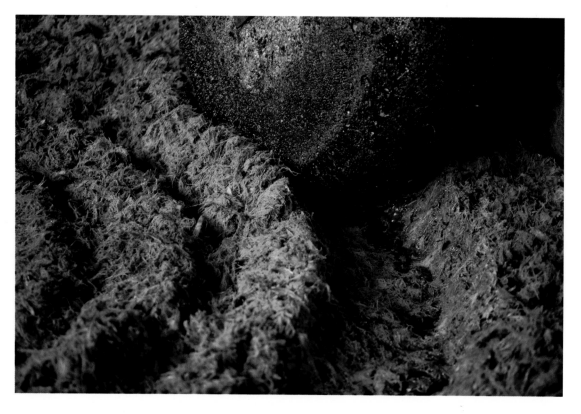

LAS HUELLAS DE TAHONA ⸻ TRACES OF TAHONA

Arandas, Jalisco

✦

LA TAHONA DESEQUILIBRADA ⸻ UNBALANCED TAHONA

Arandas, Jalisco

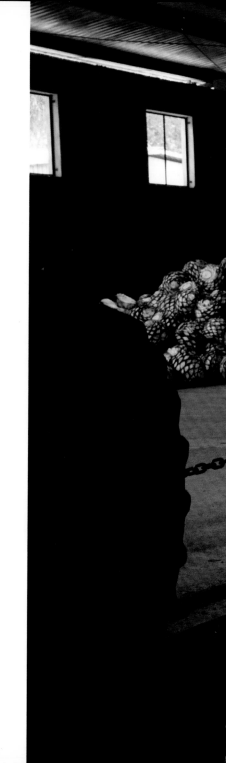

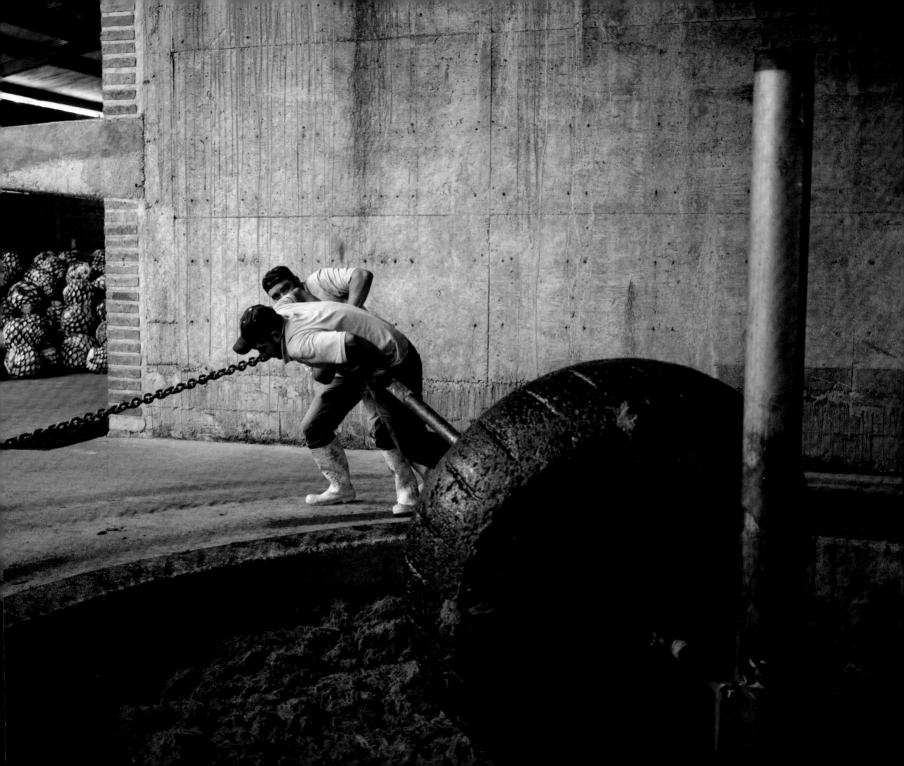

LA MOLIENDA · THE GRINDING

Tequila, Jalisco

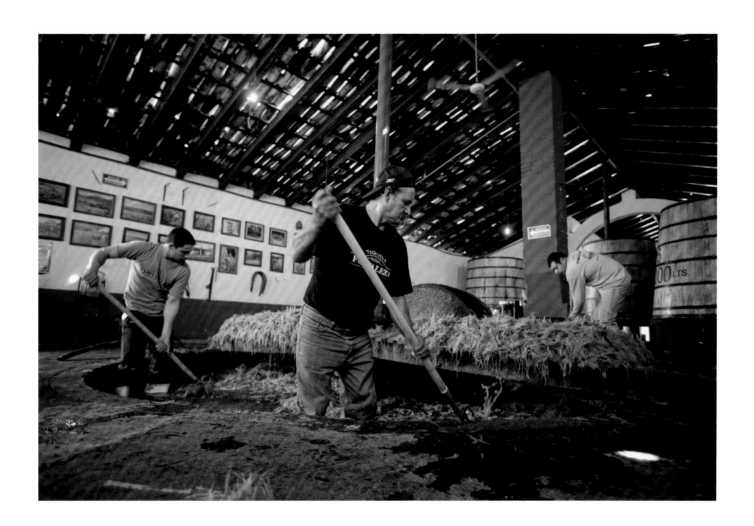

LA TERRAZA ❀ SUN TERRACE

Tequila, Jalisco

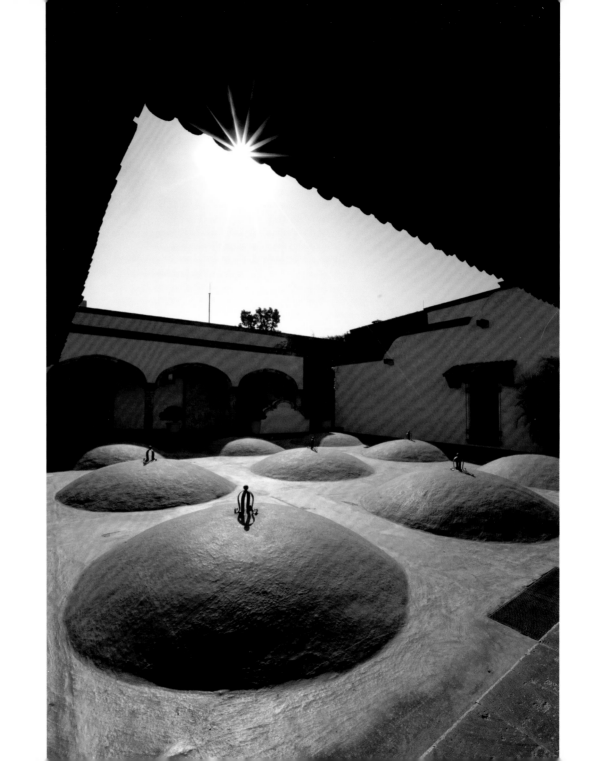

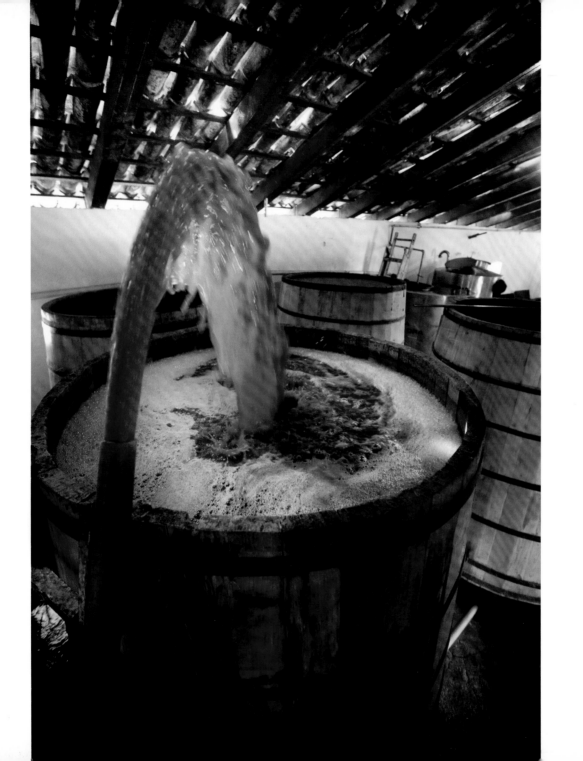

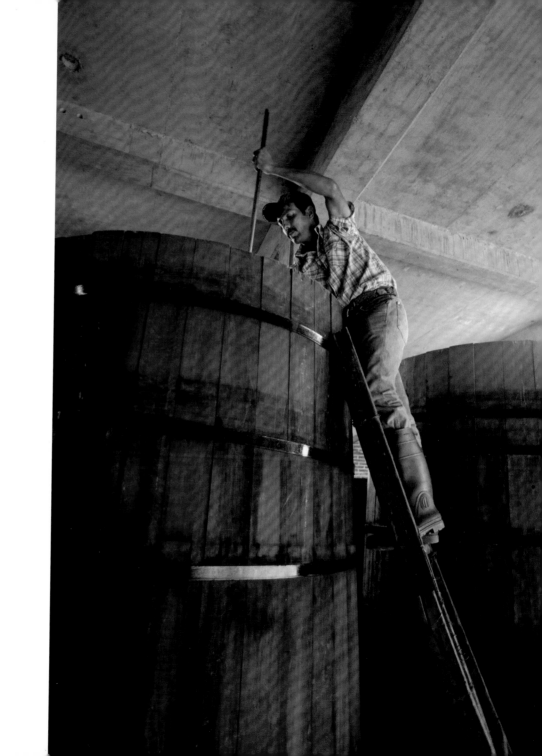

LA FERMENTACIÓN ⁊ FERMENTATION

Arandas, Jalisco

🌾

EL AGUAMIEL ⁊ AGAVE JUICE

Tequila, Jalisco

EL TEQUILERO ✦ THE WORKER

Arandas, Jalsico

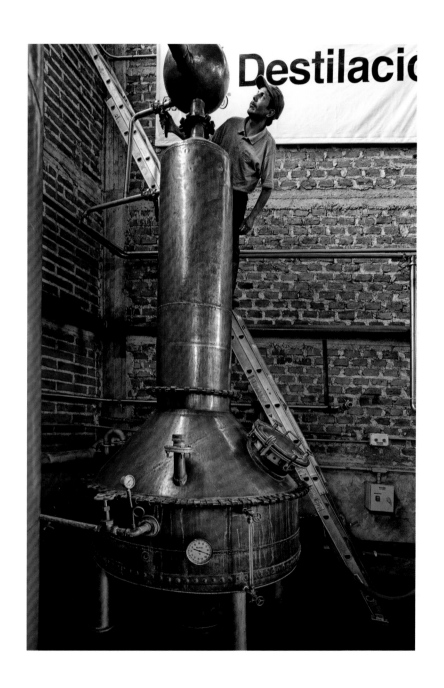

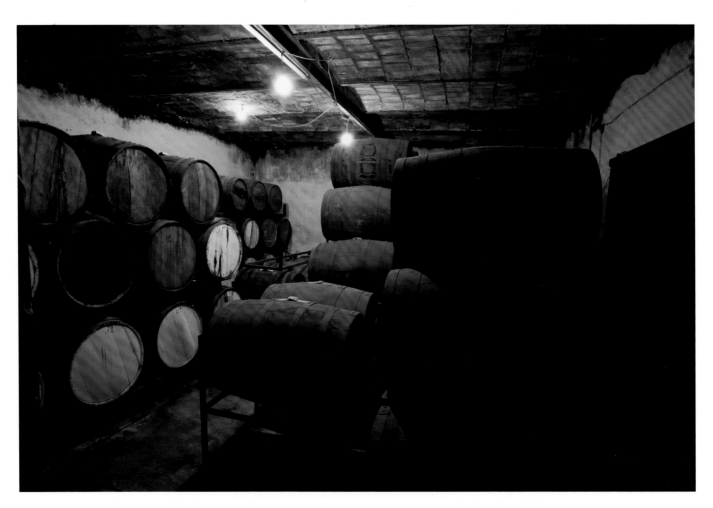

LOS BARRILES 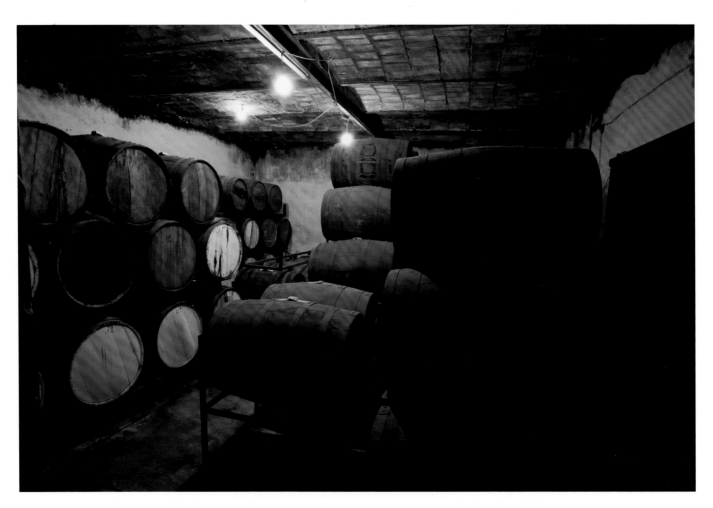 BARRELS

Amatitán, Jalisco

BAJO LA LUZ IN THE LIGHT

El Arenal, Jalisco

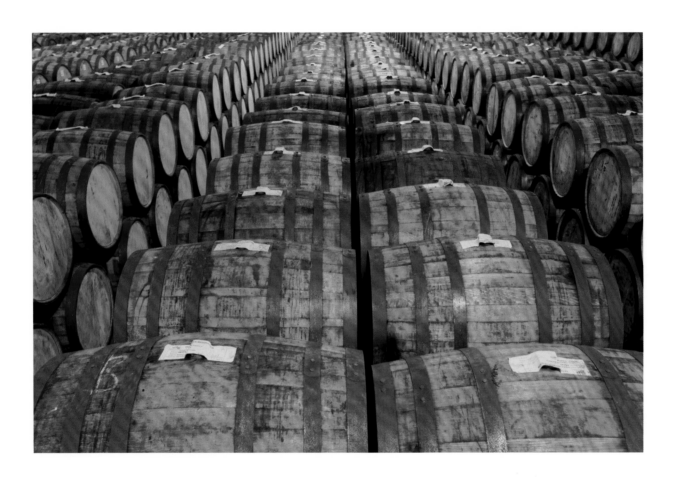

EN RESERVA ⟩ IN RESERVE

Atotonilco el Alto, Jalisco

EL ALTAR DE TEQUILA ⟩ ALTAR FOR TEQUILA

El Arenal, Jalisco

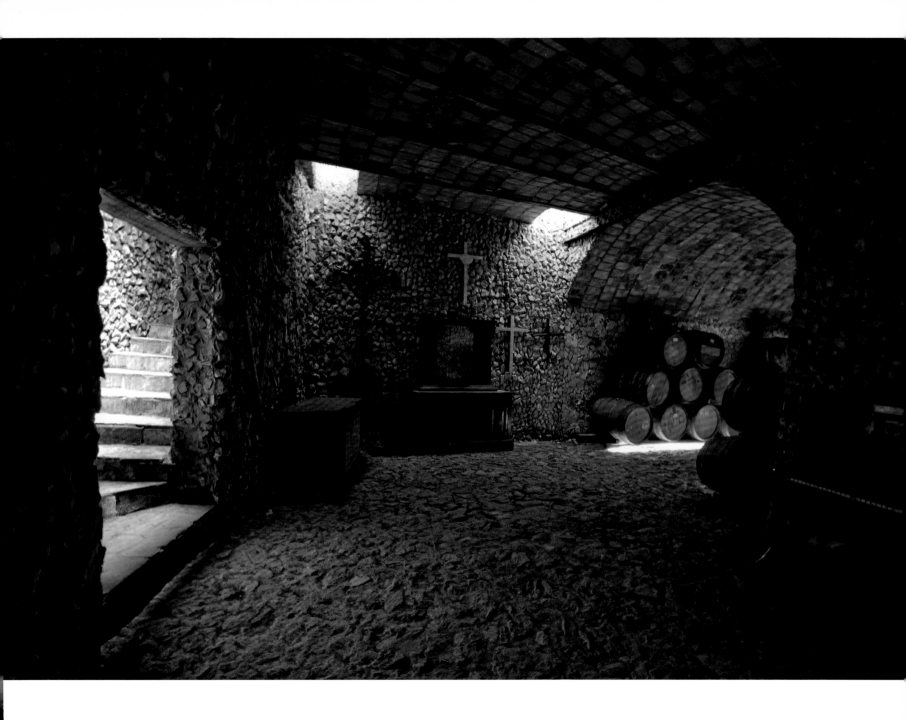

RESERVA DE LA FAMILIA　　FAMILY RESERVE

Tequila, Jalisco

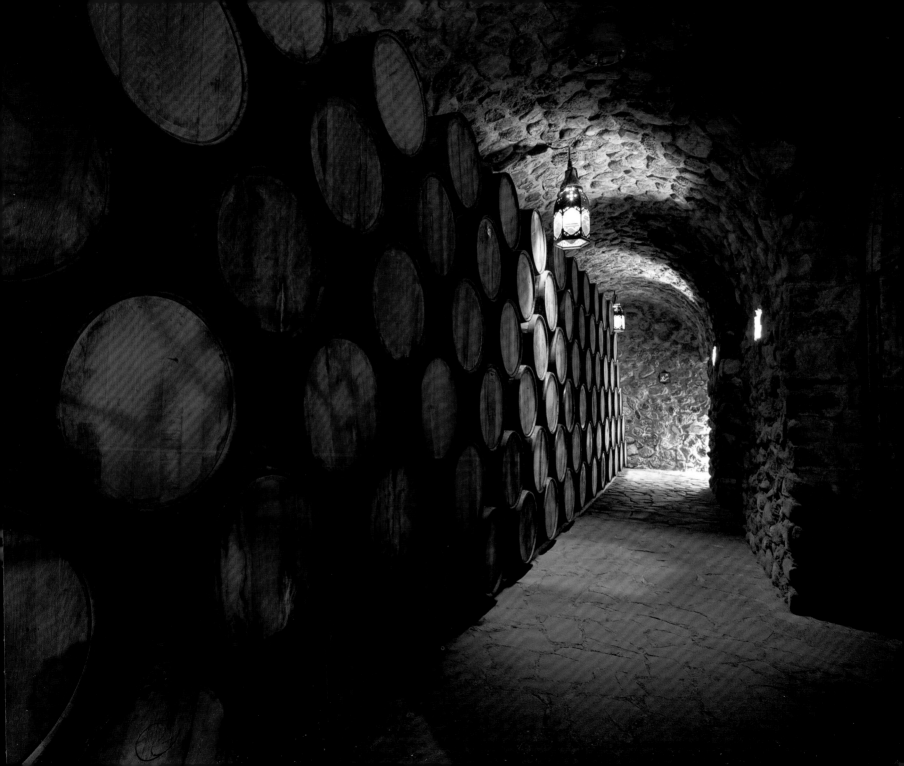

EL BURRO DONKEY

Amatitán, Jalisco

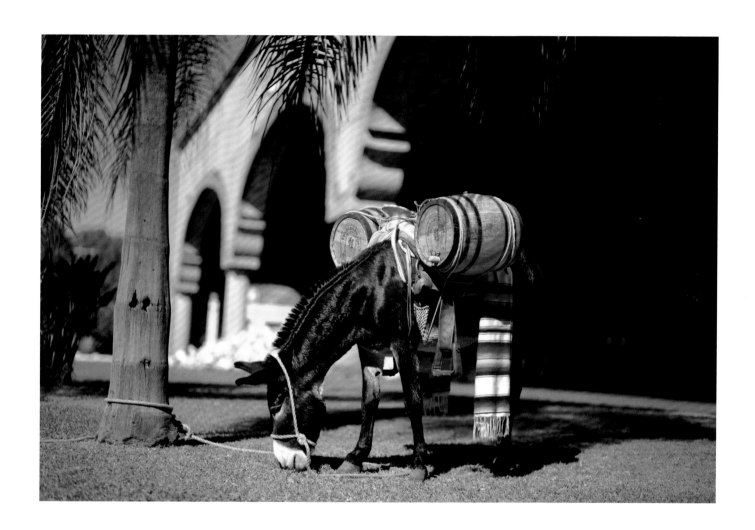

It was easy to see that Francisco had lived a few years—fifty-nine, to be exact. He was a no-nonsense weekend charro who doubled up during the week as the watchman and gatekeeper for a distillery in Arenal.

His face wore the scars of time with raw elegance. His body spoke tales of horsemanship, of drinking and afternoon charreadas.

The morning I saw him, Francisco wore a fine starched charro shirt with two horseshoes stitched in gold, one to the right of his heart and the other to the left. There was no doubt that between those two horseshoes raced his pride and his Mexico. A true charro at the doorstep of tequila.

I arrived in Atotonilco el Alto, in the highlands of Jalisco, home of some of the best tequila distilleries, where the iron-rich soil, elevation, and climate favor the blue agave plants. Standing guard to the agave fields is the pitahayo cactus, which eventually morphs into a spiny tree bearing the exotic pitahaya fruit. Most of Mexico's beauty is entrusted to ancient and adolescent landscapes where sunlight, blue agaves, and the pitahayo claim their territorial majesty.

Atotonilco el Alto refuses to surrender its rich culture and tradition to modernity. Everywhere I saw indigenous cornucopias of corn, tamales, champurrado, tacos, and roasted pumpkin seeds,

of corner stores with treasures of chile-infused candy and pan dulce. Strings of *papel picado*, paper banners, fluttered under the spell of colors radiating from a fiery collision between the indigo tint of dusk and the deep orange of a mercury streetlamp.

On a cool December evening a raucous crowd gathered to commemorate the apparition of Mexico's beloved Virgin of Guadalupe. A nervous group of young and old surrounded *el torito*, a traditional wooden makeshift bull armed with a small arsenal of fireworks and explosive chasers. When the torito is hoisted atop a man's shoulders, it takes on a life of its own and begins chasing anything that moves—like a brave bull would instinctively do.

With one violent swing of the bull's head, the fireworks rocketed into the waiting crowd. Ghostlike revelers danced in and out of the smoke, possessed by wild exhilaration. In this moment euphoria triumphed over every man, woman, and child.

In Amatitán, I walked to the town's quaint cemetery near the entrance to Hacienda Herradura in the hopes of finding the tomb of a famed charro or tequilero. Instead I found fire—a burning bush in the middle of a cemetery. A mirage of tequila on fire, that same fire of conquest and revolution, the conquest that gave birth to the character of Mexico and tequila itself.

CHARRO, CABALLO, Y TEQUILA ❦ CHARRO, HORSE, AND TEQUILA

Arandas, Jalisco

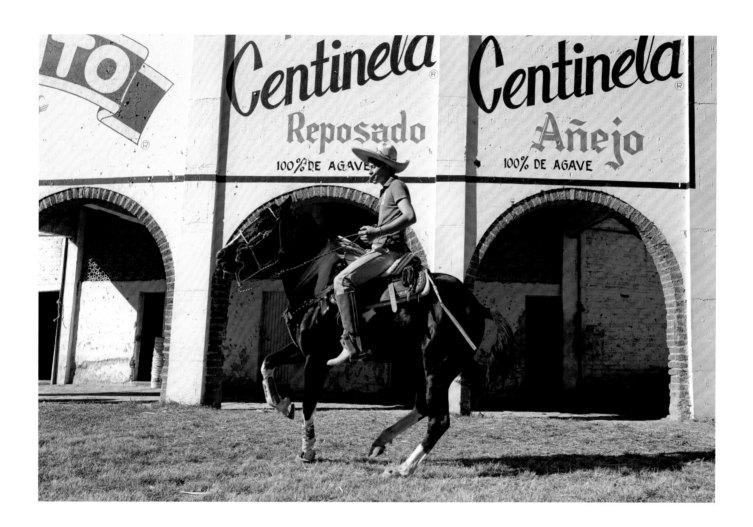

PASO A PASO STEP BY STEP

Amatitán, Jalisco

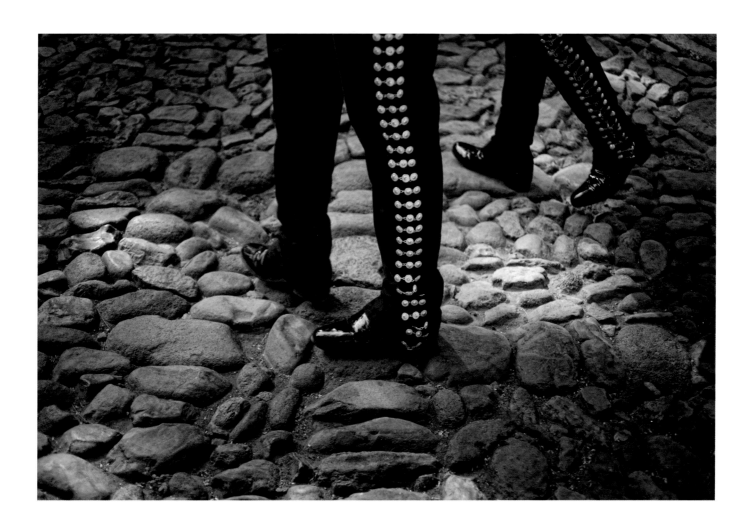

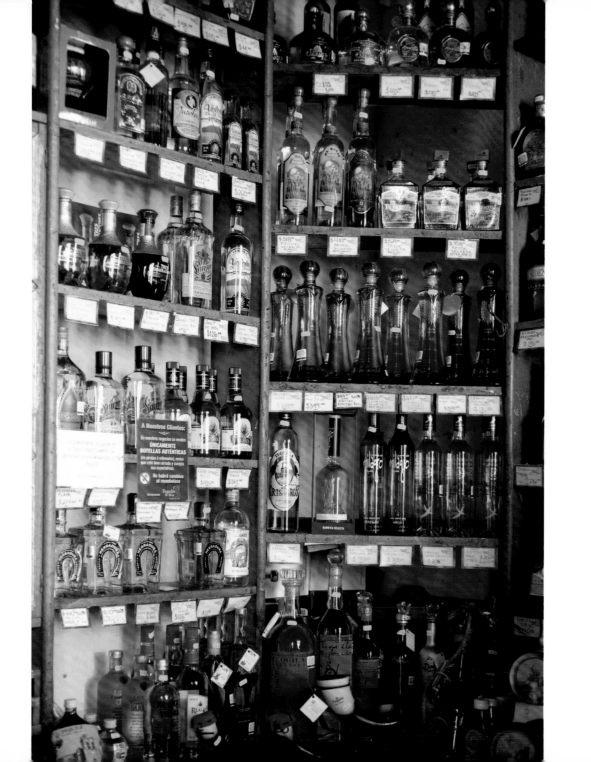

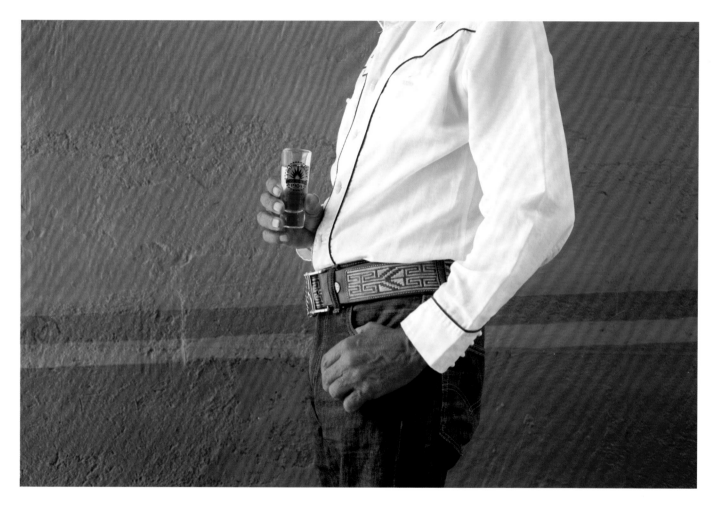

FRANCISCO CON TEQUILA · FRANCISCO WITH TEQUILA

El Arenal, Jalisco

LAS TEQUILAS DE TEQUILA · TEQUILA'S TEQUILA

Tequila, Jalisco

LA SILLA CHAIR
El Arenal, Jalisco

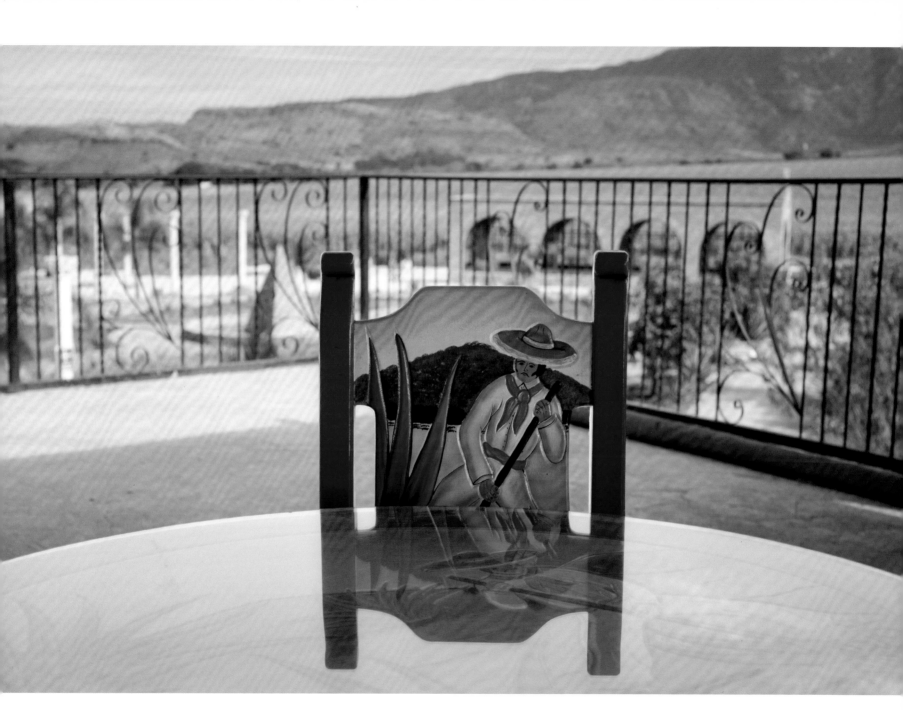

LOS COLORES DE FIESTA *FIESTA COLORS*

Atotonilco el Alto, Jalisco

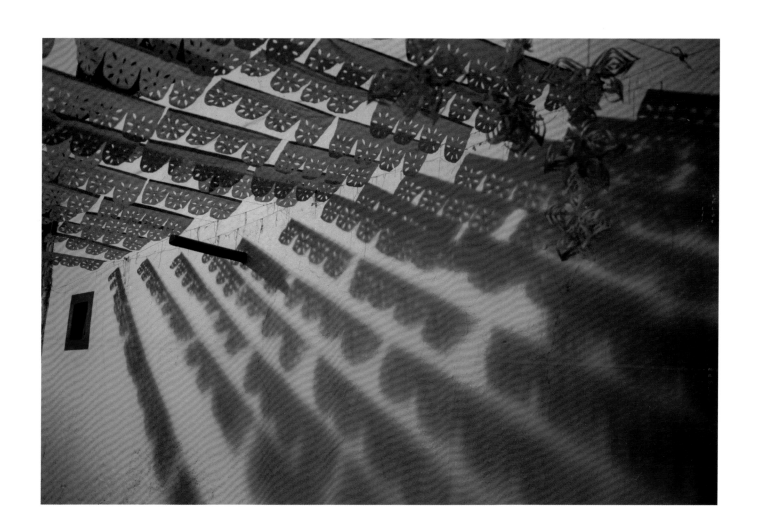

EL ANUNCIO ❦ THE ANNOUNCEMENT
Tequila, Jalisco

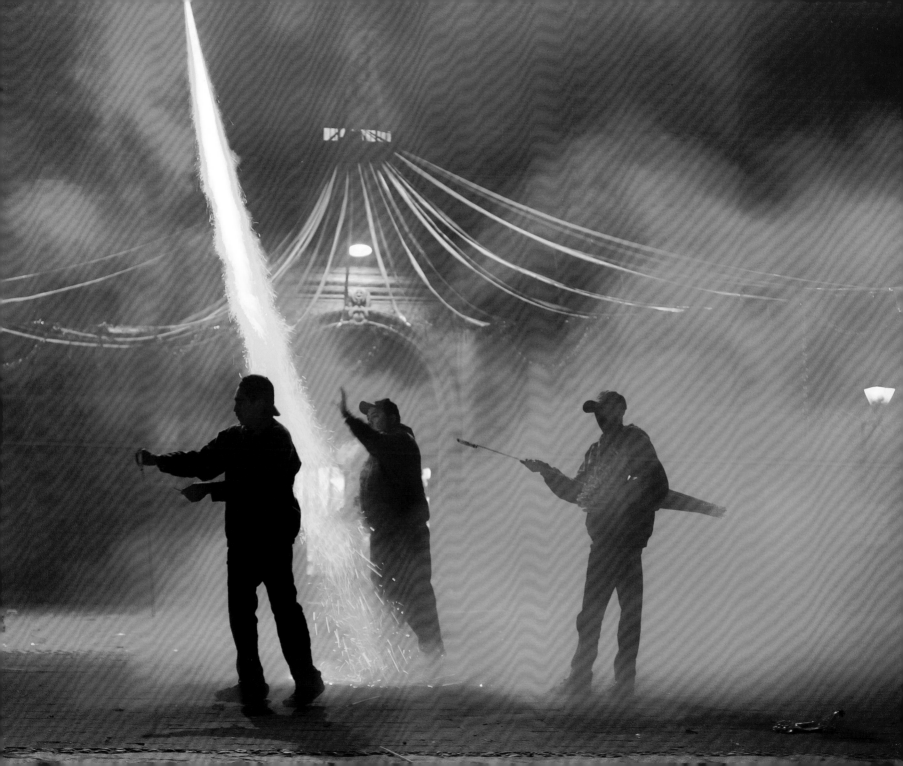

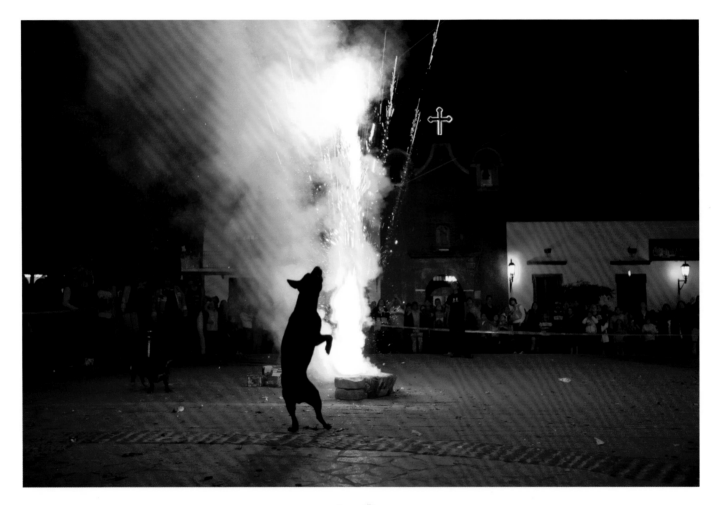

PERRO EN EXALTACIÓN ❧ DOG IN EXALTATION

Tequila, Jalisco

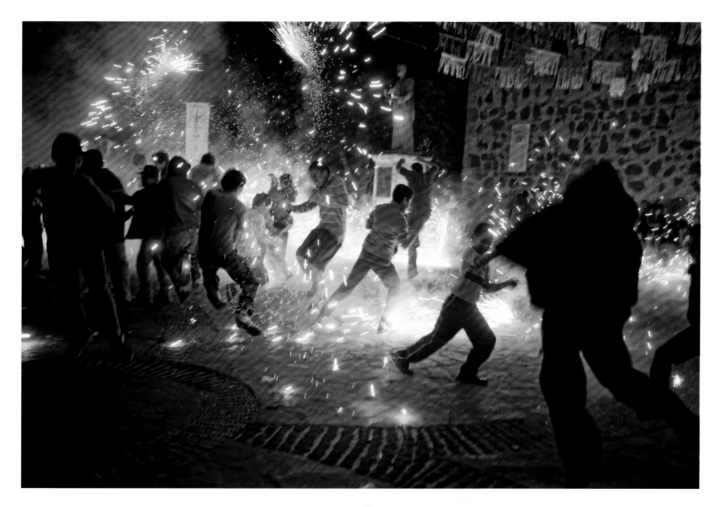

LA EUFORIA ✳ EUPHORIA

Tequila, Jalisco

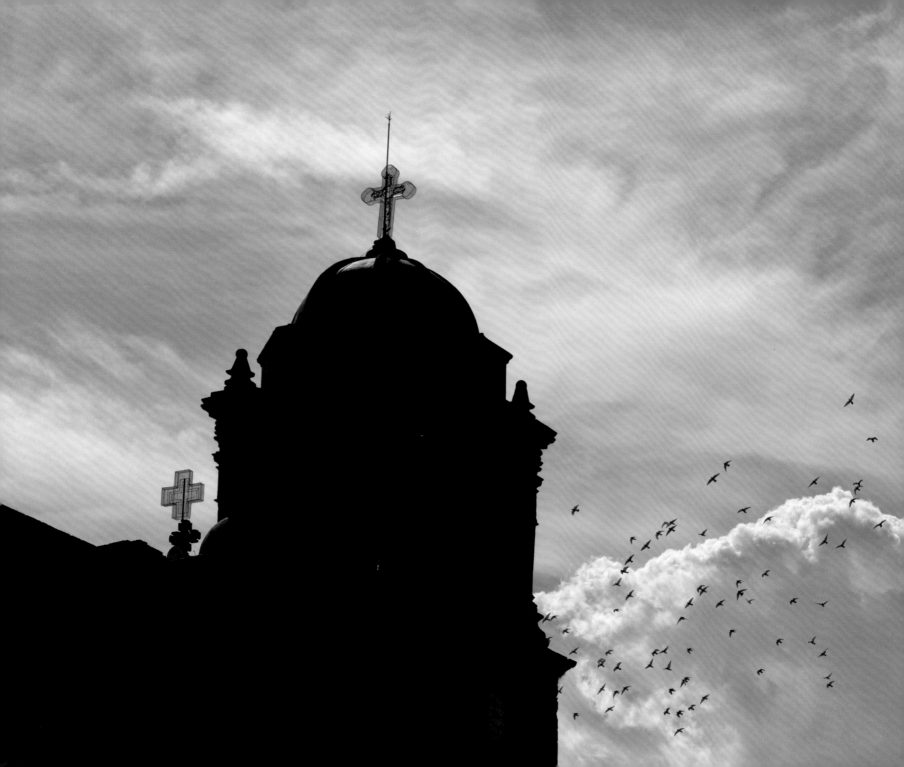

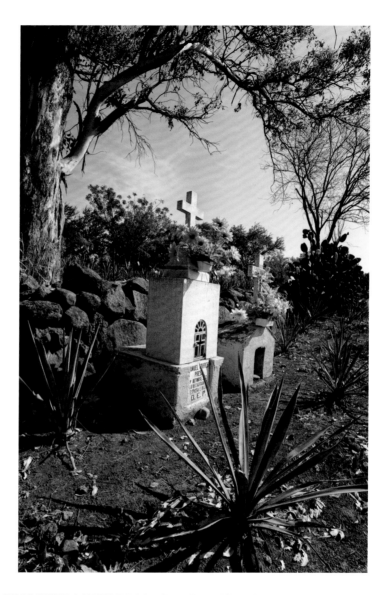

DESCANSADO ENTRE LOS AGAVES ⁊ RESTING AMONG THE AGAVES

Amatitán, Jalisco

EL CIELO ⁊ THE SKY

Tequila, Jalisco

LA VIDA ARDIENTE ❋ ARDENT LIFE

Amatitán, Jalisco

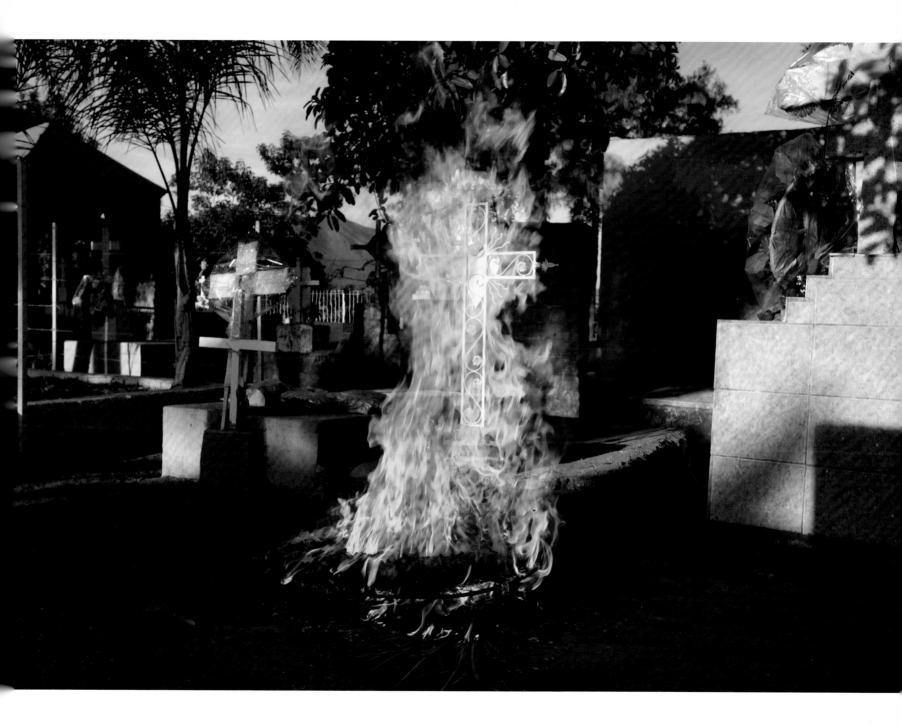

¡VIVA MÉXICO!

Arandas, Jalisco

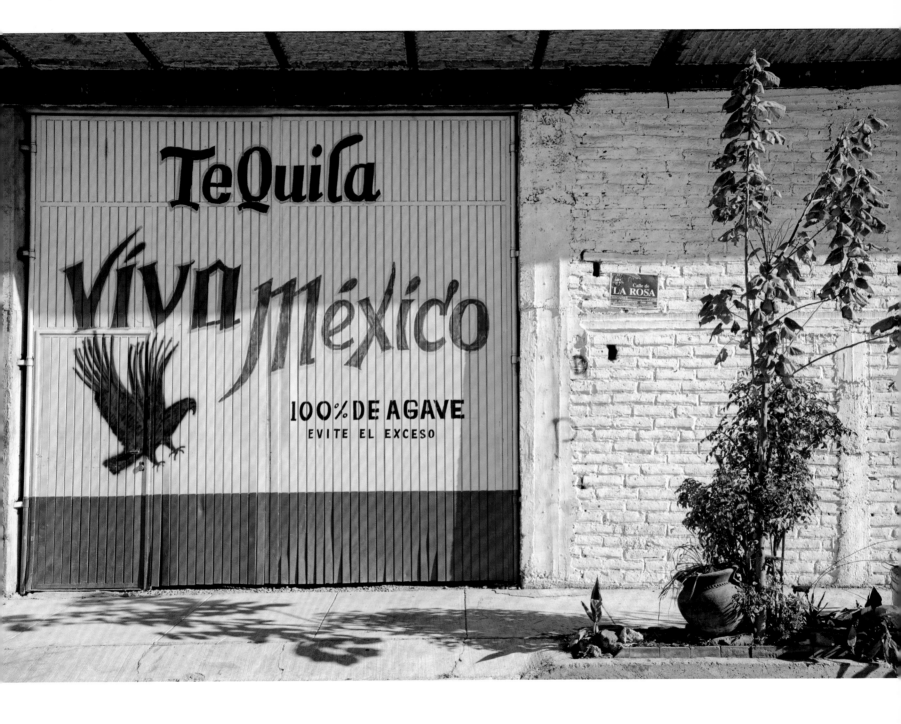

With camera in hand, pleading for moments that can be relived in perpetuity, I have met plenty.

This photographic suite is primarily born of film, of transgressions in time and the consequence of light. The glamour of a digital camera is abandoned, and art must be defined in the space of a twelve-exposure roll of film.

The intellect leans toward making photographs worthy of transcending time. These twelve plates reflect that incessant noble pursuit called fine art.

LA NOPALERA ✻ PRICKLY PEAR TREE

Arandas, Jalisco

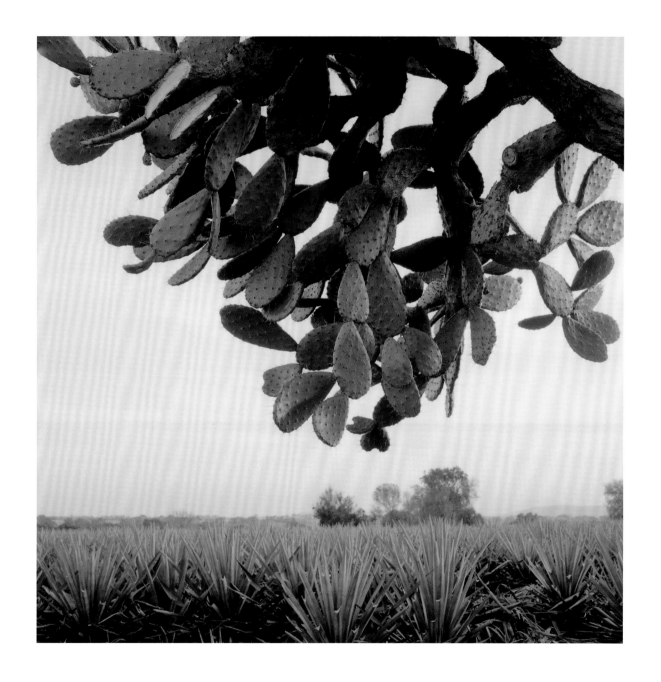

AL AMANECER · AT SUNRISE

Tequila, Jalisco

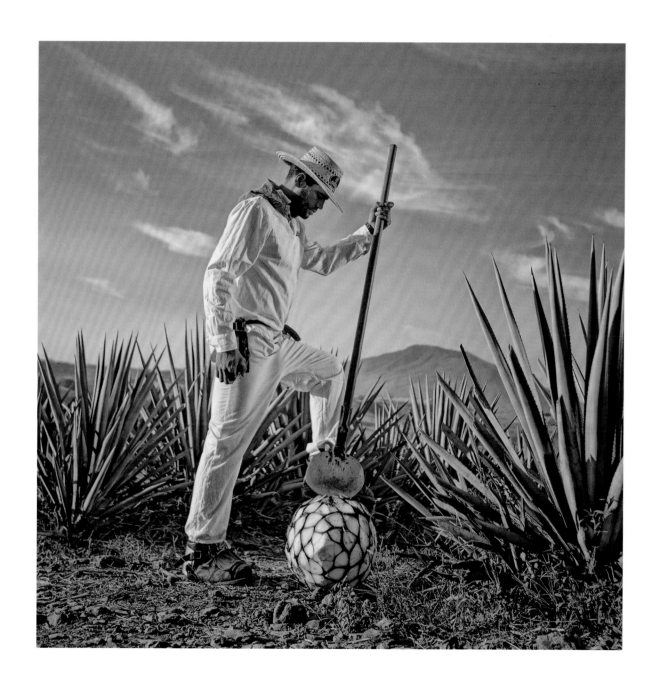

EL NIDO THE NEST

La Barca, Jalisco

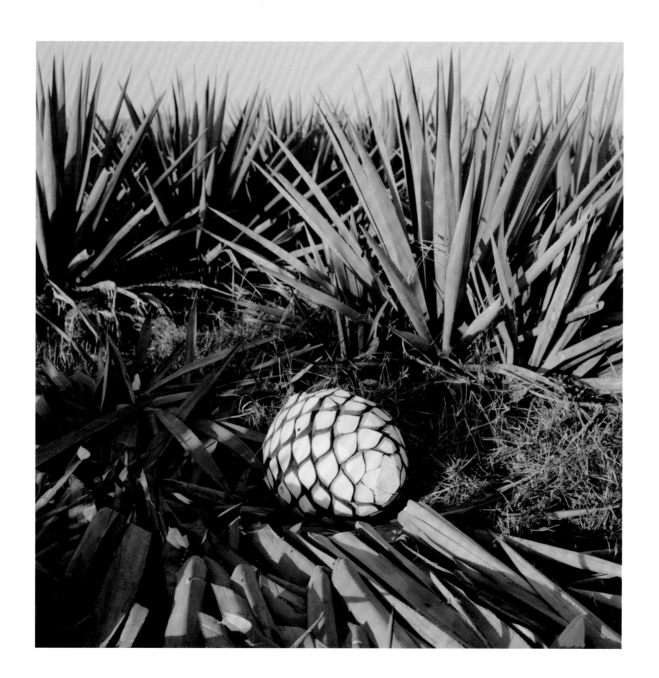

EL SILENCIOSO · THE SILENT ONE

Arandas, Jalisco

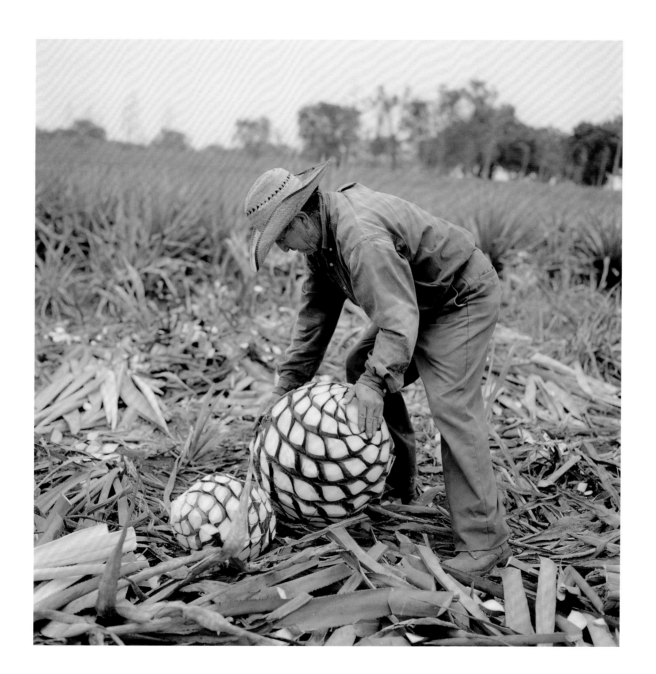

EL SACRIFICIO DE MAYAHUEL MAYAHUEL'S SACRIFICE

Amatitán, Jalisco

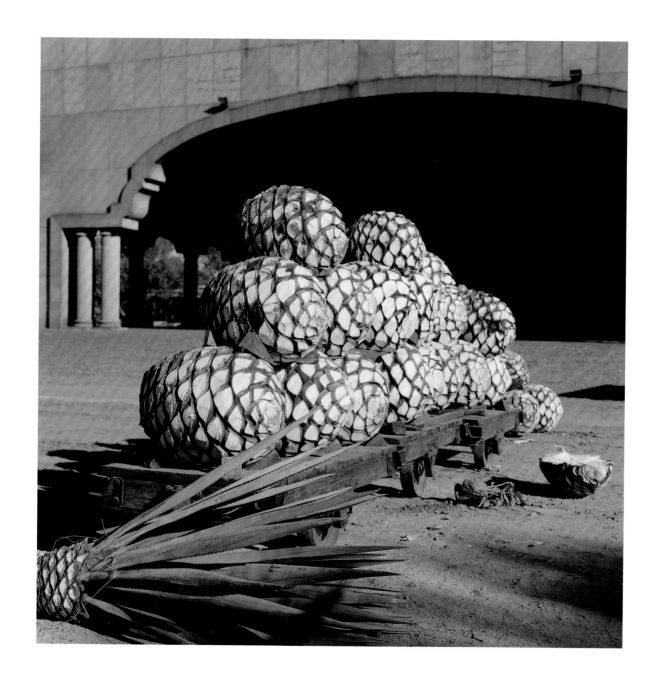

HEMBRA Y MACHO FEMALE AND MALE

Arandas, Jalisco

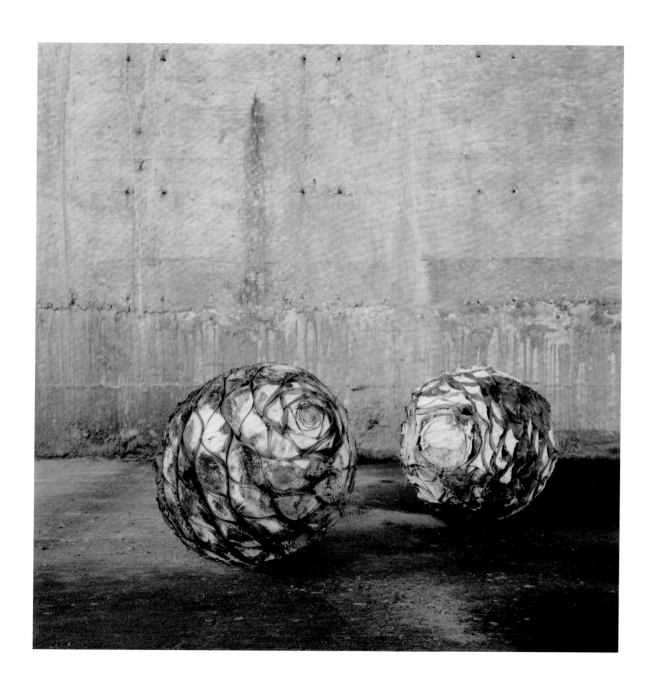

EN CASA DEL AGAVE ⚘ PLACE OF THE AGAVE

El Arenal, Jalisco

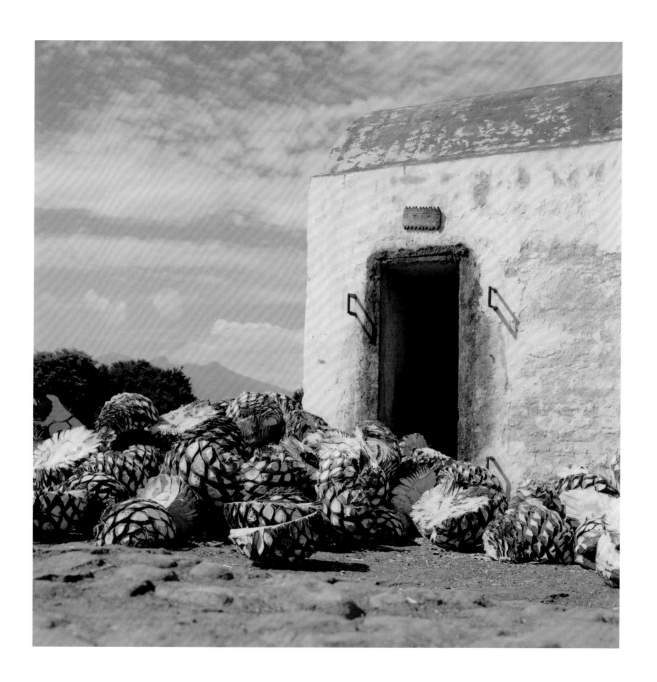

EL CENTURIÓN ✾ THE CENTURION

La Barca, Jalisco

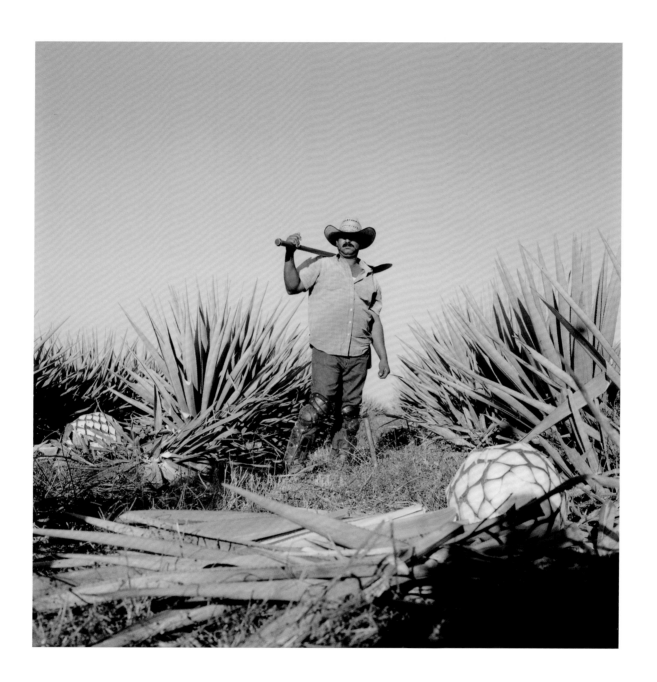

¡AGAVE, LEVÁNTATE Y CAMINA! AGAVE, GET UP AND WALK!

El Arenal, Jalisco

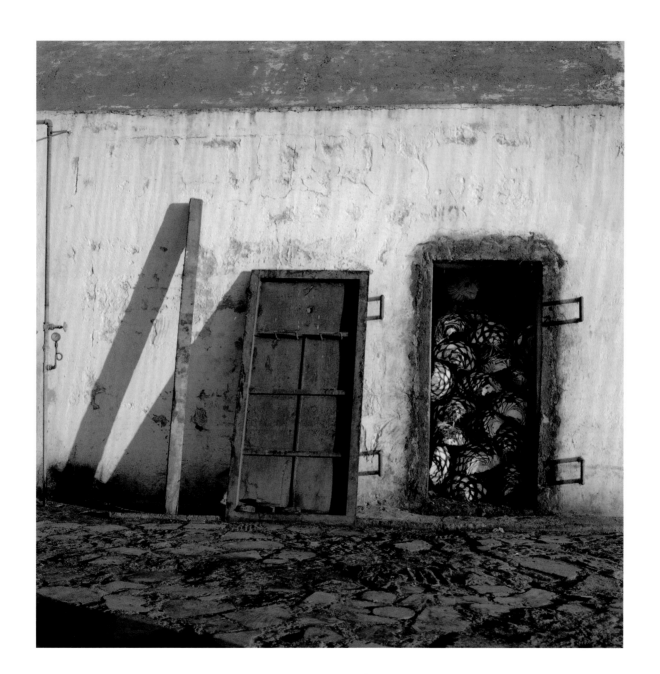

LA FORTALEZA ~ FORTITUDE

El Arenal, Jalisco

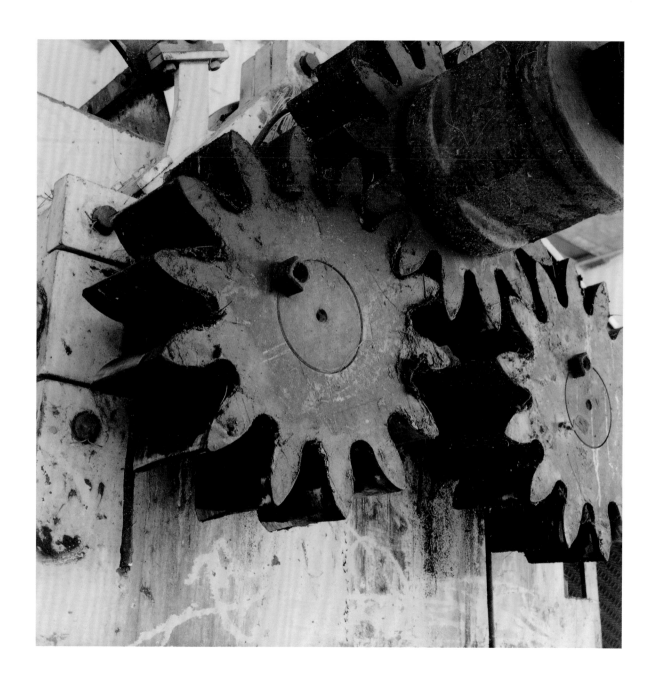

LA TAHONA ✶ THE GRINDSTONE

Arandas, Jalisco

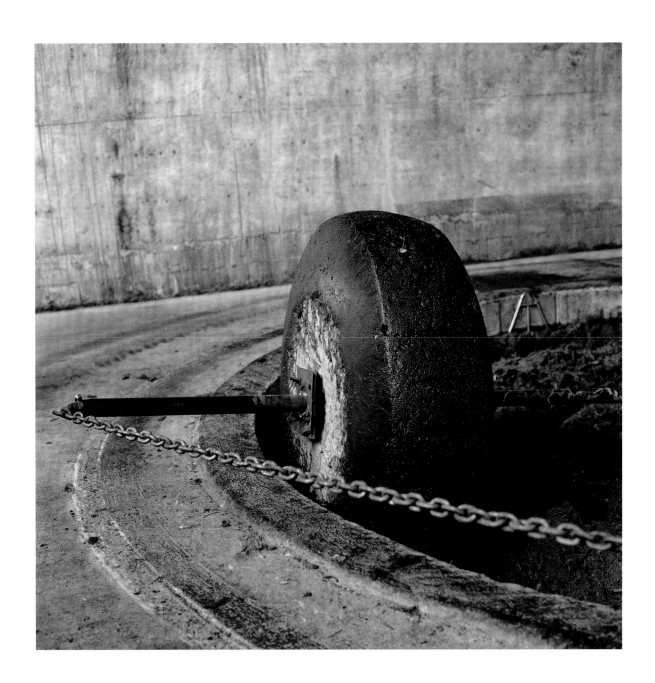

EL AGAVE EN REPOSO AGAVE AT REST

El Arenal, Jalisco

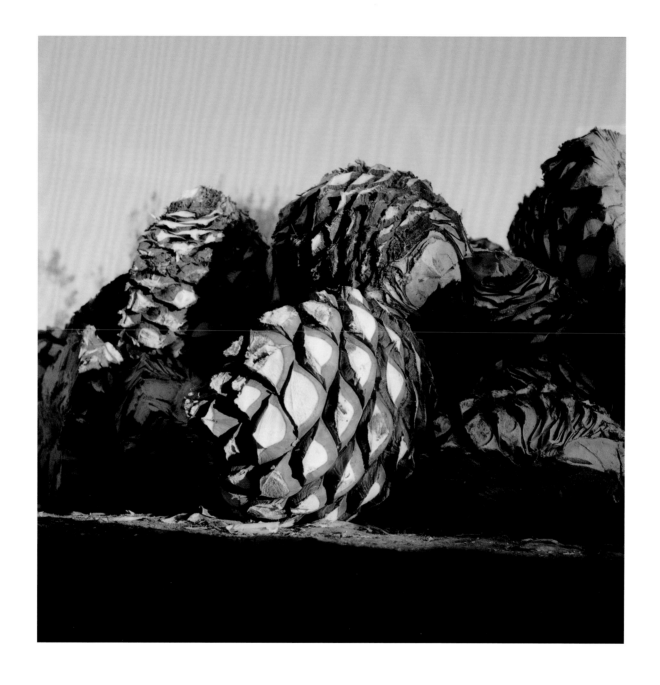

Published Trinity University Press
San Antonio, Texas 78212

Book design by Kristina Kachele Design, llc
Cover: Tequila typographic design by Rob Story

ISBN 978-1-59534-823-4 hardcover
ISBN 978-1-59534-824-1 ebook

Printed in China by Four Colour Print Group, Louisville, Kentucky

Trinity University Press strives to produce its books using methods
and materials in an environmentally sensitive manner. We favor
working with manufacturers that practice sustainable management
of all natural resources, produce paper using recycled stock, and
manage forests with the best possible practices for people, biodi-
versity, and sustainability. The press is a member of the Green Press
Initiative, a nonprofit program dedicated to supporting publishers
in their efforts to reduce their impacts on endangered forests,
climate change, and forest-dependent communities.

The paper used in this publication meets the minimum require-
ments of the American National Standard for Information
Sciences—Permanence of Paper for Printed Library Materials,
ANSI 39.48–1992.

CIP data on file at the Library of Congress

21 20 19 18 17 5 4 3 2 1

JOEL SALCIDO grew in Mexico and the United States. As a staff photographer for the *El Paso Times* he documented the Tarahumara Indians and covered the 1985 earthquake in Mexico. He has also traveled extensively in Latin America for *USA Today*. His photographs appear in the collections of the Museum of Fine Arts Houston, the El Paso Museum of Art, the University of Texas Harry Ransom Humanities Center, and the Wittliff Collections at Texas State University. Additional acquisitions have been by the Federal Reserve Bank, the University of Texas at San Antonio, and the University of International Business and Economics in Beijing. The photograph *Atotonilco el Alto* was recently added to Mexico's National Art Heritage Series. Salcido lives in Austin.